foci

foci interviews with ten international curators
by carolee thea

apexart curatorial program

Published 2001
by Apex Art
Curatorial Program
291 Church Street
New York, NY 10013
www.apexart.org

©2001 Carolee Thea

Edited by
Carolee Thea and
Gregory Williams

Designed by
Mats Håkansson

Printed in Belgium
by Snoeck-Ducaju &
Zoon

ISBN: 0-9704071-5-7
Library of Congress
Control Number:
2001088808

Apex Art
Curatorial Program
is a non-profit,
tax-deductible
organization.

Cover: Alighiero e
Boetti, *Cieli ad alta
quota*, 1993. Alighiero
e Boetti and the
Museum in Progress
in Vienna, in coopera-
tion with Austrian
Airlines and Asea
Brown Boveri, pro-
duced this work in six
versions which were
reproduced in the
in-flight magazine
Sky Lines; passengers
could ask for the
picture in jig-saw-
puzzle form. The
puzzles were made
the same size as
the folding tables
in the airplane.
Photo: Bill Orcutt.

foreword | **barry schwabsky**

Most people, remarks Harald Szeemann, "look through the ear." That's a lament, of course. Everyone knows that an art lover's goal is somehow to commune with the art without any dependence on another person to explain it or even point it out—but how many of us ever meet that goal? Here and now, in the imperfect present in which almost all of us are insufficiently acquainted with art (and those who love it most may be, perhaps, most aware of their limitations in this regard, and correspondingly avid for any help in overcoming those limitations), we need to use words to help each other. We need to listen.

In order to make the best use of this book, then, you will have to "look through the ear." You will have to let the words of the curators whom Carolee Thea has interviewed show you something about the art they care for, and about the exhibitions they have made in order to communicate their feelings about that art. But for that to happen, paradoxically, you will also have to "listen through the eye," to turn Szeemann's phrase inside out. I can't think of a better way than that to describe reading (and especially the kind of reading whose goal would be to imagine the unheard voice behind the printed word), for it's in the nuance of the speaking voice that the speaker's attitude toward what he is saying can emerge. Even more important than the idea one has of art is the feeling that justifies the idea.

What is a curator? What does a curator do? Some of the possible answers will be found in the pages that follow, and there is no need for me to anticipate them. But an outsider's perspective—I am not part of the tribe of curators; as a critic, I observe them from a distance—may make a useful supplement. It seems to me that a curator is someone who brings together things, and sometimes also people. By bringing things together in a considered way, taking into account everything that is antagonistic as well as compatible in the things brought together, the curator is something like a collector. How do things fit together? What is the space created by the differences among them? "How would you justify," as the art theorist Thierry de Duve once mused, "putting Manzoni's cans of *Artist's Shit* in the same museum as Bonnard's *Nude in a Tub*?" And yet the curator is different from the collector—and not only because the exhibitions organized by a curator have only a provisional existence; after all, many curators are also involved in developing collections for their institutions, and these collections are likely to remain together far longer than those amassed by private individuals. The difference is really in that old-fashioned Kantian idea of disinterestedness.

The integrity of the collector is precisely that he "puts his money where his mouth is," as the saying goes. By contrast, the curator's integrity lies in an investment that is only of attention, effort, and, perhaps, reputation. What he shows does not belong to him, and therefore his "collecting" is free, and can have the character of an experiment.

This ideal of disinterestedness is something that the curator shares with the critic. The critic's "job of work" (the phrase comes from the literary critic R. P. Blackmur) is to articulate whether and to what extent various things count, in his own view, for art. The curator does the same, representing her own view of art to the public. (To the extent that a critic works for a publication that may represent a certain tendency or viewpoint, to the extent that a curator works for an institution that may have a given history and a position, there is always the possibility for tension between the critic's or the curator's own viewpoint and the one she is compelled to propound publicly.) The difference this time, of course, is that the curator presents her understanding of art primarily through examples. Although she may write about what she has done, the presumption is that what she has chosen to exhibit and how she has chosen to do this should tell its own story. For the critic, on the other hand, however respectful of the artist's work, the object must eventually flatten out and shrink to become a mere illustration; his words should carry their own weight. A critic's work may outshine that of the art that has inspired him (we remember Constantin Guys, if at all, because of Baudelaire's essay "The Painter of Modern Life" and not the other way around), but I'm not sure that the same could be true of a curator. "Hate the art, love the show?" I suspect only the reverse is possible, a failure of the curator's efforts.

If the main difference between the critic and the curator is that the former works mainly with words and the latter, mainly with objects, then isn't the curator, finally, something like an artist? True, the curator doesn't *make* the object—but then neither need the artist, as Duchamp and so many others after him have taught us. Indeed the object need not be made at all, as Lawrence Weiner has said; or it can made by anyone at all, as in *do it*, which Hans-Ulrich Obrist refers to, an exhibition of works taking the form of instructions to be realized *ad libitum* by the personnel at each of its venues. This is a more difficult distinction to make than the one between curator and collector or the one between curator and critic. Perhaps it comes down to nothing more than whether someone cares to claim for himself the designation "artist" or bestow it on another.

Reading these interviews, I hear between the lines a tone of respect
toward the figure of the artist, a kind of romance that is very far indeed
from any sort of postmodern critique of individual authorship. A curator
of contemporary art works not so much with objects after all, but with
artists—one might go so far as to say that the artist is the medium in
which the curator works. And for that to be so, the curator needs to be
believe in the artist, in a touchingly traditional way—the way painters
believe in paint. And why not? "I think that one should try to believe in
things," as Jorge Luis Borges advised his listeners when he lectured at
Harvard University, "even if they let you down afterwards."

introduction | carolee thea

The exploration of identity within today's globally oriented culture has led artists and curators to develop diverse strategies and languages for negotiating spaces of artistic expression, intellectual critique, and humanistic concern for their own societies. While the artists and their works provide the elements of the cultural landscape, the curators are the creative mediators who absorb, organize, and feed information into the evolving network of exhibition systems: the biennials, art fairs, museum exhibitions, and special projects.

As the shift from an industrial to a cultural economy takes place in numerous urban environments, the main stations for display and consumption—the cities—are experiencing a changing relationship to the world; one that has obliged them to reconsider their own native cultural vitality. For some, the international exhibition system provides a welcome form of revitalization, though for others the effect of cultural tourism can seem to operate exploitatively, and at the expense of this cultural self-definition.

The ten interviews in *Foci* cover a wide range of topics that are fueled by the coincidence of the millennium, and by the anxieties and instabilities occurring within this general period of transition. They include the role of architecture and technology in shaping art; the impact of scientific trends (such as biotechnology) on cultural practice; the reexamination of identity in terms of nation and gender; the digital revolution and the demise of modernist and utopian models. As the curators discuss the exhibitions they have created, the shifting meanings of terms such as *globalism* and *center/periphery* are explored, along with the influence of the geographic realignments brought about by the disintegration of the greater Communist bloc and the mounting visibility of Asian cities.

During the past decade curators have grappled with these and other momentous changes. The title of the book, *Foci*, a plural form of focus, alludes to the multiple perspectives and approaches espoused as they execute their new exhibitions. Its slightly awkward pronunciation (fo-*sī*´ or fo-*kī*´) also offers a metaphor for the reality of cultural and linguistic translations that influence the orchestration of large-scale shows in unfamiliar locations.

It is fitting that Harald Szeemann, the standard-bearer of change within the great European curatorial tradition, should lead off this edition. Ever since Szeemann declared his independence by resigning his directorship of the Kunsthalle Bern in 1969, he defined himself as the first—and one of the most important—independent curators of the 20th

century. Hou Hanru represents a new generation of innovative curatorial
thinkers. Originally from Beijing, he moved to Paris a decade ago and
entered a burgeoning *trans-identified* community of Asian artists and
intellectuals. His ideas regarding the meeting of Eastern and Western
philosophical contexts and the evolution of Asian cities have made
Hanru a significant international voice in the next chapter on cultural dif-
ference. The Japanese curator Yuko Hasegawa offers a jolt to tradition-
al Western thinking in her discussion of the "genetics" of the collabora-
tively driven Eastern world, as well as in her views concerning gender.
Vasif Kortun, an alumnus among the curators of the Istanbul Biennial,
talks about how he has continued to keep this multiethnic city on the
Bosporus abreast of contemporary art issues, before and after the bien-
nial event. Mária Hlavajová, a Slovakian, is an enlightened and articu-
late spokesperson regarding the complex psychology behind Eastern
European art and the challenging nature of curatorial consensus. The
Barcelonan Rosa Martínez has forged new contexts for exhibition are-
nas that expand the field of vision into spaces that can engage with the
politicized culture in unexpected ways. She is one among the growing
number of bold and intelligent female spirits in a league that was once
dominated by European men. Hans-Ulrich Obrist departs from the tra-
ditional by interrupting the straightforward ideas of *display*. His many
exhibitions also highlight historical precedence in the contemplation of
perfect and imperfect museological practice. Dan Cameron, the Senior
Curator at the New Museum for Contemporary Art in New York, reflects
on his past and present multicultural interests that have contributed to
bringing Latin American art and once unrecognized contemporary artists
to his dynamic institution. Barbara London, involved in new media since
the 1970s, discusses video, digital art, and technology in international
exhibitions and the increasing transformations caused by rapidly evolv-
ing modes. For the last thirty years, Kasper König's talent has informed
and enlarged the practice. His interview, which took place in Frankfurt
at the time of *Sculpture. Projects in Münster 1997*, was an inspiration
that propelled my continuing research.

 In addition to exploring larger cultural themes, the curators speak of
the roots that have shaped their personal styles. They also discuss the
sources from which curatorial ideas stem; the artist as pawn or catalyst
for inspiration versus the curator as mediator between the artist and
society; how artists are selected for shows; collaborations and consen-
sus; the obligation to educate viewers, patrons, sponsors, collectors,

and bureaucrats to support an encapsulating vision of a history.

I want to thank the ten participants for their willingness to discuss their methods and motivations. Glenn Harper, my editor at *Sculpture Magazine*, has been extremely supportive of this project from the beginning. I am also grateful to Steven Rand, Executive Director of Apex Art Curatorial Program, Sandra Antelo-Suarez at *Trans>arts.cultures.media*, Jack Sonenberg, Leo Steinberg, Joe Dezzi, Gregory Williams, Richard Lynn, Gabrielle Stellbaum, Holly Zausner, Suzanne Fox, Muffet Jones, Heather Felty, Warren Niesluchowski, Doug Thea, Jane, Tom, Erica, Josh, and Zack Shandell for their affection, encouragement, and enthusiasm.

harald szeemann
06/2000

The artist's work is a seismograph of change in a society. When con-
templating an exhibition, the curator must have a finger on the pulse,
aware of the collective concerns of the moment as well as the history
associated with an artist and his or her narrative.

Yes, I also think that the curator has his own evolution. When you're
doing exhibitions for 43 years, you come to a certain point. The *facteur
Cheval*[1] said that with 43 years a human being reaches the equinox of
life and can start to build his castle in the air, his *"Palais idéal."* From this
moment on, even if you do a show with contemporary artists, you want
it to be not just a group show but one that becomes a temporary world.
And maybe this is why my exhibitions become bigger—because the
inner world is getting bigger.

Yes, it is true that the changes you see with artists' works are the
best societal seismographs. Artists, like curators, work on their own,
grappling with their attempt to make a world in which to survive. I always
said that if I lived in the 19th century as King Ludwig II, when I felt the
need to identify myself with another world, I would build a castle.
Instead, as a curator I do temporary exhibitions. We are lonely people,
faced with superficial politicians, with donors, sponsors, and one must
deal with all of this. I think it is here where the artist finds a way to form
his own world and live his obsessions. For me, this is the real society.

At the turn of the last century there was a schism between art and tech-
nology; at the turn of this century there is a reunion. Aside from prag-
matic information, the Internet has become a fantasy, a dream machine
for the wired masses and a catalyst for globalization. What do you think
about the effect of this technological revolution?

This new technology makes an illusion of globalization, but again it cre-
ates social splitting with those who can use it and those who cannot. You
see it with everyone who thinks they can be playing the stock exchange
and, in a mouse click, be richer. But new rules are made by others who
are in control, and the riches dissolve. It's the same exploitation that has
always been going on, except it's virtual.

In art we still have to go see the original object and discuss it with
the artist. New technology does not know how to deal with the erotic
element, art which is spatial. This was always a problem. Think of Robert
Ryman: He was always reproduced badly but the originals were beauti-
ful. We're finally very old-fashioned—we must go around looking at orig-
inals. This is absurd, but it's beautiful. When video appeared, I was writ-
ing an article and I thought back to when I was a student. Hundreds of

us had to go through the same books to find certain masterpieces; we
marked our findings with pieces of paper. If there were video or the Inter-
net, it would be easier not to have to look through a thousand books—
wonderful! But with art itself, we must go to the three dimensions.

However, the reproduction, the virtual, and the fictive exist. They con-
tinue to destabilize the original while digital technology shrinks the
world's borders.

Globalization is perfect if it brings more justice and equality to the
world… but it doesn't. Artists dream of using computer or digital means
to have contact and to bring continents closer. But once you have the
information, it's up to you what you do with it. Globalization without
roots is meaningless in art.

Do you mean, by roots, the individual narratives within the global village?

Well, yes. An artist like Jason Rhoades uses technology, but he brings it
into the service of the personal, as in the evocation of his father's gar-
den. The art is a new interpretation of something that possesses him.
Also, a lot of things in the Internet are verbal. Only 5% is visual. The
majority of people look through the ear. If you make a guided tour you
have to look at their eyes to see if they know. The Internet is good for
information, but it never replaces the eye contact, which also character-
izes the history of cinema. But it also overloads you with a lot of trash.
In a recent interview, Jeff Bezos[2] defined "Internet" as a narrow hori-
zontal level of competence over all industrial fields. He compared it with
electricity at the beginning of the 20th century, increasing speed for some
things while revolutionizing others. Also, the digital image has extend-
ed possibilities. For me it is mainly information, but not art in itself.

Jason's accumulations, composed of a variety of technologies, often
camouflage a narrative.

That's what I like about his work: that he's not isolating an object,
ambiguous objects, "polybiguous" objects—showing us that we all have
the obsession to consume. All these objects in a structure, that is his
obsession—maybe his cock, the garden of his father, a hemorrhoid, or a
blood vessel. It's no longer Duchamp's *pissoir*, which is isolated.
Accumulations were a revolt against Duchamp, but again, they too
became an object, a strategy to make a new object—as it is in Jason's
case, albeit a temporary one. Of course you have inner rules, like a muse-
um of obsessions that is in your head. Then there are the freedoms or
constrictions that we have from place to place. For instance, I can work
in the North as a freelance curator, but in the South, I must accept the

position of director, as is the case for the Venice Biennale.

Tell me about this process of becoming director.

It's very interesting. I was asked to be freelance curator at a museum in Zurich. Everybody thought I was ambitious and wanted to take over the post of the director. On the contrary, I wanted to do exhibitions that I liked and give a reputation to the institution. As a curator, I didn't have to take on the administrative struggle of a director.

You are considered the first independent curator. How did this occur?

In my case it was a rebellion aimed at having more freedom, because I already had eight years as the Director of the Kunsthalle in Bern. Well, I was Director, but we didn't say *director*. We wanted to open up the institution as a laboratory, more as a confirmation of the non-financial aspect of art. Then I made *documenta 5*, which is considered the end of a career.

Yes, to curate this exhibition, more than others, is to open oneself up to enormous scrutiny.

Frankly, if you insist on power, then you keep going on in this way. But you must throw the power away after each experience, otherwise it's not renewing. I've done a lot of shows, but if the next one is not an adventure, it's not important for me and I refuse to do it.

As a curator, you've managed to realize a profusion of groundbreaking exhibitions. You seem to possess an internal compass connected to the psyche of artists and their ideas. Who are some of the new artists that you might consider as the barometers of change—artists that you might be thinking about for the Venice Biennale of 2001?

I always took artists with sensibilities that serve as a seismographical element in our society. So when I did thematic shows like *Bachelor Machines* in 1975, *Monte Verità* in 1978, '83 and '87, *In Search of Total Artwork* in 1983, *Visionary Switzerland* in 1991, and, in 1996, *Austria in a Lacework of Roses*, it was to show that the artist's work functions like a lot of things in our society. There's a visualization of the closed circuit, now within the scope of gene culture. For a moment, this was reduced to cryonics, survival, and the abolition of death. But it is the artist's closed circuit of energy, their interior world, which goes on and on. There can be Duchamp and his *Large Glass* [1915-1923], but there was also Jules Verne. Can you imagine one of the guys in a Verne story observing the sky and discovering a new star at noon while his wife and children were knocking on the rocket hatch to announce that lunch was ready? You see, this is a "bachelor" aspect and a rebellion against procreation. I always wanted to do another exhibition after *Bachelor Machines*, called

Louise Bourgeois, *Torso*, 1996. Courtesy
Venice Biennale. Photo: Christopher Burke.

La Mama. I had a sponsor for the show. It was an insurance company, but when they learned the show was more about erotics than procreation, they took the money back.

It was in 1975 when I had the dream of the ideal society. With the medium of exhibition you can show a personal, biographical, utopian idea. That was my idea for the *Monte Verità (Mountain of Truth)* exhibition on a hill in the canton of Ticino: a home for utopians, anarchists, and eccentrics where individual projects presented utopias of an ideal society. It was here where you got the feeling that these people were interpreting their lives as a total art work. Given a weaker situation—a hill, not a mountain—you give another importance for yourself to this existential situation. When I resume these exhibitions of Ascona and the Mountain of Truth, we'll first reveal the material or alchemical guys, then the religious ones, the life reformers, and, finally, the artists. The artists will paint the landscapes (which the bankers buy), but then the bankers want to live there, too—where artists had their beautiful, bohemian days. Then architecture follows and the shit begins. That's really always the history of these parallel things, be it Capri, Taormina, Taos, or Ascona. It's why I did this third exhibition where the geniuses dreamt of a fusion of the arts to dissolve this individualistic behavior; a dream of a new society that believes the fusion of art is a new form of life.

The institutionalization of conceptually oriented installation art and expanded museum spaces as renovations of old histories are a link to understanding the democratization of art as a challenge to the museum's elitism. In 1986 you took over unconventional premises, most frequently gigantic: former stables in Vienna, the Salpetrière hospital in Paris, the palace in the Retiro park in Madrid. You invited artists to set up dialogues between their work and the chosen spaces.

In Venice I was glad I had white-cube spaces, but I also had the Arsenale, where the artists had to accept the historical space as it was. From the space problem came the question of the demand for objectivity and intervention, and to give life to memory.

You are speaking of the old maritime spaces opened up for the Biennale: Corderie, Artiglierie, Tese, Depositi Polvere, Isolotto.

Yes, it's many-layered. At the Arsenale, the Commander was great. He said, "all this, a city within a city, for marines that never won a battle." These are historic buildings: one from the 16th century and the rest, Austrian or Napoleonic. During the last number of years in Venice, this was all about the survival of the institution of the Biennale. If you stay

only in the Giardini,[3] you maintain the nationalist aspect, and for the
institution to survive the 21st century, new spaces were needed.
What does it mean to be the Director of the entire Biennale after being an
independent curator for so long?

Well, in Venice, only when you are Director can you show what you want.
In '95, I wasn't Director and the planned exhibition, *100 Years of Cinema*,
finally didn't take place. I worked for the Biennale in different years.
Nineteen seventy-five was *Bachelor Machines* and I discussed it with
Vittorio Gregotti when he was Director. It's a bureaucratic issue. Of
course, the contracts never came on time; I had to get money from a
bank and I paid the interest. Finally, I gave all museum contracts to the
bank and the museum paid the sum, which was 15,000 Swiss francs,
directly to the bank. There are the usual delays in Italy with contracts, so
we first started the exhibition in Bern, although it was produced for
Venice. At this time I was taking over new spaces for art, specifically
Magazzini de Sal, the Salt Deposit. In 1980, we were five curators. The
theme was the 70s. At that point I told them that we are in a moment
where things are changing, so let's not stop with Stella and the German
painters. I told them we had to do *Aperto*[4] or I would leave. The *Aperto*
was not just a salon for artists under 35; I showed Richard Artschwager
and Susan Rothenberg, Ulrike Ottinger and Friederike Pezold.
The 1999 *Aperto* certainly did not seem to concentrate only on young
artists. Louise Bourgeois, Dieter Appelt, Dieter Roth, Franz Gertsch, and
James Lee Byars were among your choices.

The Biennale of 1999, *dAPERTutto*, was more in the spirit of the first
Aperto, not limiting young art to under the age of 35. I was the first sin-
gular curator that postdated the committee that ran or curated *docu-
menta 5*. I have always thought that if biennali want a future, they should
emulate the structure of *documenta*. And today, the oldest biennale—
in Venice—when faced with so many biennali, should be the youngest.
At *documenta*, finally, does the curator have autonomy from the
bureaucratic duties?

Until 1968, there was a huge *documenta* council; its founder, Arnold
Bode, was a "degenerate" painter under Hitler. They wanted to show
Germany what they missed in the "thousand years" of Nazism. After
1968, the council became quite absurd. They were missing many impor-
tant issues and it was for this reason that they asked me to be the artis-
tic director. But all the former *documentas* followed the old-hat, the-
sis/antithesis dialectics: Constructivism/Surrealism, Pop/Minimalism,

Realism/Concept, etc. That's why I invented the term, "individual
mythologies"—not a style, but a human right. An artist could be a geo-
metric painter or a gestural artist; each can live his or her own mytholo-
gy. Style is no longer the important issue.

It was in 1969 that you curated the exhibition, *When Attitudes Become
Form: Live In Your Head*. It presented, for the first time in Europe, artists
such as Beuys, Serra, and Weiner. With this exhibition, the process of
conceptualizing the art work was made manifest. It was also at this time
that you became an independent curator.

Yes, it was in March, only a couple of months after the end of *docu-
menta 4*, when I curated *When Attitudes Become Form: Live in Your Head*.
How can you do this biggest exhibition in the world, *documenta 4,* and
miss showing the works of these new artists? So I did it in Bern in March.
Of course, this made a big impact. Then I was asked to do the next *doc-
umenta* with my own strategy. I dissolved the committee. It costs a lot to
convene a committee of forty people, and half are never present, any-
way. Also, it's cheaper when one person travels to see colleagues and
explore what is new in their region.

Then *documenta* became the first one of this new style. It became
the image of the curator, which gave an image to the show, the show of
an author. In Venice, I also felt that we needed a good start like in the
60s and 70s—a complete change of structure—so I suggested that we
adapt to this new system in 1999. I dissolved the national spatial unity
of the Italian pavilion, causing a lot of trouble in Italy, where it was felt
that a foreigner was destroying their country. But the artists preferred
this. They didn't like being only with Italians. They wanted to be with
their international colleagues, where they learned more and were more
competitive.

Yes, clearly globalization or multi-culturalism doesn't simply begin with
a term, but rather with a force that—brought to consciousness—illus-
trates a social concern. After suffering the difficulties of the bureaucra-
cy, why do you feel that now in 1999 and 2001 you are able to take the
position of Director of the Biennale?

Even though I am an independent curator, I would take on the director-
ship because Venice is worth making the effort. The structure goes from
a state organization to a foundation, and you're always faced with the
bureaucratic structure and financial problems. Now the Biennale is not
only the visual arts; it incorporates architecture, film, theater, dance, and
music, and there is enough space in the Arsenale to include the other

arts. The Biennale is interested in continuity and collaboration among
the arts, not only in isolated big events; it will become a laboratory and
a place of creation. This is the future.

Yet it's always the same in Venice: They promise you the space on
January 10th and give it to you on May 10th. They're doing renovations,
patching all the walls and opening the roof. When all is done, you will
be able to walk through from the Corderie to the Artiglierie. And now
they're restoring Isolotto, where Serge Spitzer's installation was.[5] This
installation was fascinating. Where once to see art only frontally dis-
gusted everyone, now some artists with a theatrical touch show in
spaces where you can see only a frontal view from the entrance.

How will the Biennale in 2001 be different from that of 1999?

When you work with artists for 40 years, it's no longer just a collabora-
tion, but a going-together. I have cut off my attitudes of 1968 last year, so
perhaps this will be an opportunity to show artists that were important
figures from the late 60s on. But also there are the two new theater-like
spaces, so you can play on the notion of performance. I have proposed
to begin with two buildings that will form an international exhibition,
with a "Plateau of Humanity": half theatrical and half projected. The
entrance to the exhibition will be given a large space that would cover
theater, social problems, all the races, what man can do to man, and then
you are free again to give another accent, one from your unconscious.

There are other ways of describing globalism, of being together.
For instance, in old Paris, the Russian Ballet was a collaboration between
artists, including Diaghilev, Picasso, Picabia, Satie, and Nijinsky.

Yes, collaborations have become quite significant in the dialogue of
globalism. Does this early-20th-century model influence the way you
will choose your artists for the Biennale?

Well, I'm a European. It's very strange that when you do an exhibition
like the Biennale last year, you have only four months to make the show.
So you cannot normally travel around the world. You go to the artists
you want to show; you visit them and discuss the space or you have them
come, so there's no problem. In my months I did lightning trips and dis-
covered some things at the last minute, like the two Serbian girls, Tanja
Ristovski and Vesna Vesic. Although it was last-minute, it was very actu-
al because of the war. Théy were very sad. The Serbs were despised peo-
ple in the world and these girls were compelled to be artists. It was like
being in a second stage of seismographic culture. In the end, you must
leave yourself open—to keep spaces free and to make room for surprise.

Previous two pages: Wang Du, *Strategie
en Chambre*, 1999, installation view, Basel
Art Fair, Sculpture Projects exhibition.
Photo: Carolee Thea.

Creating such a large exhibition is like making a film, but in com-
pressed time.

> I was glad when people said that the exhibition was cut like a film. It real-
> ly did correspond.

What are some of the ideas for the new Biennale?

> Well, I call it a "Platform of Humanity." So it is less a theme than a mood
> that gives to each art and artist the freedom of expression. The narra-
> tive will be, again, a walk from one surprise to the other.

Last year, there was a lot of walking involved, but this was mitigated
by surprise.

> Although one brain imagines the structure and themes, the walking
> leaves people free to decide the distance they want to take—an inner
> one or outer one. It's another way of walking. In the cinema you are sit-
> ting and with video you can stand, but if it's too long, you just sit.
> Exhibitions have a lot to do with space; the freedom is the space. In
> *Parsifal*, Wagner says, "Zum Raum wird hier die Zeit" (Here time
> becomes space).

1. The rural postman Ferdinand Cheval, born in 1836, had a vision at the age of 43 of his *Palais idéal*,
which he spent the next 33 years constructing by hand in Hauterives, Drôme, France. **2.** Jeff Bezos
is the founder of Amazon.com. **3.** The Giardini Pubblici is the traditional site for the national pavil-
ions of the Venice Biennale. **4.** *Aperto* is the international section of the Venice Biennale, separate
from the national pavilions. **5.** Serge Spitzer, *Re/Cycle (Don't Hold Your Breath)*, 1999.

Left: Dieter Roth, *Tryptichon*, 1979-81.
Courtesy Venice Biennale.

Right: Tanja Ristovski, *To Be*, 1999.
Courtesy Venice Biennale.

hou hanru
06/1999

Art functions in a place of anxiety and question-
ing: A curator's job is to discover the themes
which underlie the prevailing mood of a society.
Regrettably, some curators create exhibitions in
the service of their own ideas, contributing to
their own power.

Curating an exhibition can be a very contradictory practice. The role of the
curator contains a delicate, sophisticated, and subtle borderline. It is the
worst of circumstances to use the artist just as an illustration of your ideas.

How would you describe the curator's role?

The role is to pose a question, and the artist should participate in the for-
mation and the answering with different solutions so that the process
is a collaboration. But yes, there are moments when you can see the
excessive hand of the curator.

Is the show you did for Apex Art [New York, 1999]
with the architect Yung Ho Chang an example of
a collaboration?

In that program, I and Evelyne Jouanno, the co-curator, attempted to
analyze what occurs when a curator is asked to do a group show that
ends up being rather conventional, mainly due to the limits of budget
and space. It is a difficult condition.

Don't you usually work under a variety of con-
straints?

Well yes, it is challenging. If you have a lot of money and space it's easy
to do a standard group show. The creative aspect of Apex is that their con-
ditions test how far they can go. For me, curating is a mixture of experi-
ences coming together, and the program at Apex is a condition of timing,
finances, and spatial concerns. I decided to introduce architecture, which
is the natural result of what I've been doing in projects like *Hong Kong,
etc.*[1] and *Cities on the Move*.[2] These shows talk about urban issues, how
art can reconnect itself to visual culture, and how architecture becomes
a means to proclaim certain visions as well as to add a spatial condition.

How did you become involved in architectural
projects?

It came so naturally, because at a certain time in the early 90s all of these
kinds of selfish expressions—the body and sexuality—had become so
academic and egotistic. For me, it was a symptom of how a generation
of artists had lost the capacity to recommit themselves to reality. They
just created very enclosed circles, like masturbation.

Do you think this is a personal or cultural issue
relating to your Chinese background?

Yes, my generation of Chinese has been fighting for more fundamental
issues of humanity. For us, the first necessity of art is never to return to
the enclosure of the self. The second thing is to see how modernity
rewrites the process of social transformation in different conditions, and
then how it is visualized. Architecture and urban issues become impor-
tant because they're the most general expression of this kind of project.

At the same time, my experience gives me the opportunity to look
at a more global situation from a different point of view. The way I talk
about the relationship between art, society, and everyday life is very dif-
ferent from that of most of my colleagues in Europe and the States,
because of different personal stories. I went to art school and became
committed to this domain (it's never really a profession) because I want-
ed to contribute my efforts to change reality, to have more relevance.
Maybe visual art is irrelevant to me.

Were you trained as an art historian, a critic, an
artist, architect?

I had an interest in all these things but was trained in art history in
Beijing. I also did painting, performance, installation, and architectural
research at school. The main subject for my degree was medieval sculp-
ture and churches, how the relationship between visual art and archi-
tecture evolved because of social change.

I see a direct connection now between the work
you curated for the French Pavilion[3] and your for-
mer studies. Columns topped with a Chinese bes-
tiary jut through the Neo-Classical pavilion roof,
and there is a chariot outside. You and the artist
Huang Yong Ping have created a kind of medieval
courtyard.

Not only medieval in its form but an overlapping of two histories through
two different architectural systems. But this was not my idea; the artist
came up with it. I was so excited, because it had a resonance in the back
of my heart, and I said that he had to do this. But also because of timing
and physical conditions in Venice, we did it together.

But let's get back to Apex. We decided to do an architectural proj-
ect and to introduce a Chinese architect, Yung Ho Chang. Chang created
a site-specific installation and provided the audience with a direct and
corporeal experience of his architectural vision. It's very important that

architecture has a voice in this discourse. Yung Ho Chang spent 15 years
in the States to study and teach, and he decided to go back to China to set
up the first private architectural firm.

> This also becomes a story of how modernity trav-
> els through continents.

Modernity is a global thing, and usually the process of Western culture
has been connected to other cultures through colonization: The African
mask influenced Picasso, and Frank Lloyd Wright was inspired by
Chinese Zen and Lao Tsu, the first Taoist philosopher. When you talk
about Western modernity, it is such a complexity. Exchanges or con-
frontations with artists of different cultures help us discover universal
aspects, which can stimulate other projects. Thus, where social condi-
tions in places are different, the social exchanges are very important.

> Do you think the exchange that's taking place at
> the Venice Biennale is forced? Everyone is un-
> comfortable about the number of works from so
> many Chinese artists, similar to when Russian art
> was imposed on the Biennale.

And then it disappeared in three years. This is not the first time the
Biennale has had a Chinese presence at such a scale, but it's the first time
you have so much propaganda. The last time, for the Biennale of 1993,
the first Chinese avant-garde was exhibited in the pavilion where you
now have the press service. It was an insulting presence of Chinese con-
temporary art, which stole the name avant-garde and showed the most
cynical works. It was the first marketing of so-called Chinese Political
Pulp. There's a huge difference not only in propaganda, but in the selec-
tion and artistic interpretation of this situation. And the main progress is
that this time the Chinese works are shown inside an international show.
It's true that there are very strong Chinese artists here, ones that you
have not seen in previous Biennali, and there's also an intimate and per-
sonal decision by curators linked to personal or marketing interests.

> I understand that the Chinese works exhibited in
> this Biennale are from one collector.

Not all, but many. Two years ago, with such a heavy American presence,
no one raised the question, "Why the heavy American presence?"
American and European art has been seen for years and years, and it's
taken for granted. Why do we ask about so many Chinese? But this is
boring to me. I am more concerned with what happens in the next
Biennale; will we see the same quantity of Chinese art?

Regarding the idea of globalism, a decision was made to democratize the Venice Biennale, the bastion of the Western art exhibition system, to reflect this issue of the moment.

Until the whole thing becomes normal; then we will have achieved a kind of goal. In the French Pavilion you have Chinese and French, and that's great, but what will happen next: have an African and Icelander representing the French? But if next year people say, "We've done the Chinese thing; now let's go back to France," then that's the disaster. There are different ways of consuming this thing.

If the market and institutions come in too fast, it's the speed of consumption that becomes the subject. Globalism is a utopian concept, and strategies that take place in these brief periods bear witness to a culture returning to its roots.

Yes, but I have used this occasion to turn it into something else. There are different ways of consuming the idea of globalism. For instance, in the French pavilion, the two curators presently living in Paris, myself from China and Denys Zacharopoulos (originally from Greece), presented two art works that were very separate but functioned under the same roof, but not as a two-person show. Rather it is an enforced juxtaposition equivalent to mutual interpenetration. This is part of my personal agenda. In the past people have spoken of globalization as taking Western modernized life and economies and altering underdeveloped countries, but you rarely hear of how non-Westerners are functioning in a Western society.

Some people are expelled from their own culture, as in Kosovo, and there are those who choose to relocate.

It doesn't matter how they left their countries. What is important is that they become even more open to other cultures in their new countries and develop their own cultural context and contribute to a new intellectual and cultural scene with global significance.

There are 200,000 Chinese living in Paris. Some, like Huang Yong Ping and yourself, are making strong work integral to the scene.

He has proved that he is inevitable at the moment.

How do you react to the dichotomy of traditional versus modern cultures?

The traditional versus the modern has been an obsession in certain

Yung Ho Chang, *Street Theater*, 1999, installation view, Apex Art Curatorial Program, New York.

periods of history and development, especially in cultures where moder-
nity is a new thing; people are obsessed because there is a necessity
about it. But I think this question has been solved in life situations, where
you have to deal with it in concrete and fragmented ways. Innovation
and tradition constantly interweave. An image that people talk about is
the fundamentalist Islamic soldier who uses advanced technology to
make religious wars. On the one hand they forbid television, but on the
other they use satellites. Another image is the poorest Indian man drink-
ing Coca-Cola and wanting Nike shoes, a strange mixture of modern
Western products and non-Western traditions. We need to look at the
world in a more diverse way and use different elements as a strategy
for critical intervention.

> The mythological bestiary surmounting Huang
> Yong Ping's columns in this 19th-century Neo-
> Classical pavilion is a reference to the past. Do
> you know who the architect was?

I was told that he was an Italian mimicking the Neo-Classicism of the French.

> Huang's columns metaphorically insert the
> Chinese into the French culture; an ironic ges-
> ture, it is also perhaps a mocking one.

The strategy that Huang carries out is a fundamental aspect of his think-
ing; he uses different elements in particular contexts. In China, he organ-
ized a group called Xiamen Dada and introduced modern Western art
elements (Duchamp, Dada, Cage, and Beuys), while in the West, he intro-
duced Chinese mythologies. His employment of Chinese elements is
not to elicit a belief in them; he doesn't believe in them either. He uses
systems in a strategic way to show you that there are different ways of
looking at the world. It's a question of which system of knowledge has
been empowered, how a dominant system has become a hegemony,
how other cultures can resist this in an active way. Not only to claim their
identities but to propose alternative projects. The French Pavilion is an
example of this, using these ideologies to show another way of seeing
the architecture and its symbolic function.

> It becomes a dialogue.

And a negotiation. When you look at his version of Chinese mythology,
it's so contradictory; he shows the interior contradictions among those
images. It is a destabilizing intervention into fixed ideas.

> The contemporary art media don't always react
> to an instability, but to an intervention.

I have to work with journalists and television reporters. It's my duty to explain the work, but they always ask the wrong questions; they think the audience doesn't want to know more, so they shorthand the information. People aren't given enough time to absorb anything, and although we consume culture on the run, the brain seems to be mutating. The "body" subtext in this Biennale deals with anxiety about multiculturalism, but also anxiety brought on by digitally-encoded, biotechnological, millennial gluttony. The body is being transformed in a process of spatialization as it disintegrates into space. In visual art there are many expressions of this flux between the material and immaterial, existing only in time, in spatialization, rather than in a fixed existence. The challenge for the media, institutions, and the audience is to confront these expressions, to respect and understand them, and help make them visible. In large exhibitions like the biennial you need time, but how much time can you afford to sit in front of a video projection that lasts 60 minutes? This is a challenge to curators. Sometimes you have to do a show, and you need to view a piece five or six times to understand it, but you decide to use the piece and don't have time to view it. It can be a disaster. It's a kind of curatorial schizophrenia, to deal with this anxiety. I don't think artists are rarified; they're part of our communication system, and they play the game of this new dialogue, dealing with the issue of excessive information, lack of time and space, and how to handle it. Contradiction and chaos have the same value as reasonable knowledge. And maybe there are new art works that are challenging because they're structured in a very fragmented way. You can go into a room with a projection and spend all day with it or five minutes and say, "I've seen it"; it's an interesting

Sheng Yuan, *In Threes and Fives, or in Knots*, 1997, installation view, *Parisien(ne)s* exhibition, Camden Arts Centre, London. Courtesy Hou Hanru.

negotiation. It's important that we discuss this.

How do artists deal with this notion of time at the end of the century?

To analyze the situation in a critical way, on the one hand, is impossible and contradictory. On the other hand, perhaps it gives us the opportunity to invent new models of communication and to create new possibilities and alternatives. For instance, you can have a film that goes on for years and another for five seconds, and these can exist side by side with the same importance. Artists propose very different projects, but the goal is how to present them in a public space, and that's our job.

Are you finding new forms in artists' studios that confront the compression of time?

Forms are not a big issue for me. Any expression is fine, as long as it has something to say in the right context. A good example is the first version of Douglas Gordon's movie *24-H-Psycho* [1994], the one where he slows the Hitchcock movie into 24 hours. It's an amazing and impossible experience, because you have to be sitting there for that time. I think the extreme situation in art is beautiful. Fifteen years ago, Huang did a paradigm of this in the piece called *Photographing things you don't want to look at*. It was really an impossible situation. In a Gabriel Orozco work, the fact that he uses two kinds of "pool" tables isn't the most important point; it's that he sets up an impossible condition for you to be there in front of the work.

Do you mean time or split screen or....

Or a mental situation, a challenge whether to look or not. Like David Hammons' talk about fetish. How much will you pay for a snowball of different sizes? It is such a beautiful gesture, a touching, delicate, sophisticated moment of existence and knowledge.

Yes, it is about the contemplation of life and death, the body versus the mind.

Yes, you have to make a decision for yourself and your destiny. You can complain about power, but the extreme moment is when all of this is fading away and you still want to catch it and hold it.

And the snowball has this resonance because it's ephemeral.

It covers the issues of consumer society, cultural difference, social space, sensuality, and beauty, and you don't know how to handle it.

And it implies the body, whose temperature will melt the snow.

Previous two pages: *Cities on the Move*, installation view, The Hayward Gallery, London. Courtesy Hou Hanru.

The snowball vaporizes, is gone, and you feel a loss in your body, making you think your body should take a different form; you look at your body in another way.

> You're saying that in corporeal disappearance we can "rebirth" the mind. Do you know other artists who do this?

One piece Huang proposed, but which hasn't yet been realized, was around the glass wall at the Centre Pompidou, a clear tube sitting in the corridor between the first and second layer of glass around the contemporary gallery, in which he wanted to put hundreds of different insects that eat each other; at the end you have one or two left.

> Very fat ones.

It's like a ball rolling through the tube and almost invisible. If you stand in the wrong place, you don't see the piece, just a transparent tube. For the work to exist and for you to exist, it is a perpetual struggle and pushes a confrontation with a huge problem, an aspect of being. Earlier I spoke of being interested in urban architecture; it's such a complex system.

> How do social spaces present an opportunity for imagination and transition? Tell me about your corridor projects in Paris.

Social spaces are complexities where the individual spaces connect and network, and where certain transformations take place. The corridor project is an earlier one that I did with my wife, Evelyne Jouanno, when we had no money or place to stay in Paris. We found a small apartment on the top floor. Here there was a triangular corridor, five meters long and one meter wide with a sloping roof. When we moved into the house we changed the wallpaper and painted everything white and then questioned, why white? The main reason was what we see in galleries and museums, and now we had to figure out what to do with it. We saw this useless corridor and we decided to make it into a project area. Corridors are probably the most interesting places in buildings, because they are liquid and need defining and redefining constantly; they are also transitions from private to public space. We decided to invite a different artist each month. Yes, it was crazy, and we had to live with it. Every month we would spend a week helping get the piece done, then three weeks opening it to people. In one night we could get a hundred people. The first artist we chose was Thomas Hirschhorn, who filled the place with cardboard and wood and rubbish so that you could hardly go through it. The next artist removed the wallpaper, the window, put in gas heating and

electricity and, well, this game went on for 13 months. The only month we didn't do it was when our daughter was born.

Did your wife give birth in the corridor?

Almost. The hospital was only 100 meters away! Now we have moved out of the house. We only wanted to do the project for a year. It wasn't an alternative gallery, just the right place to raise the right question.

1. Hou Hanru organized *Hong Kong, etc.* for the 2nd Johannesburg Biennale, *Trade Routes: History, Geography and Culture* (artistic director, Okwui Enwezor), which took place in 1997-1998. **2.** Co-curated with Hans-Ulrich Obrist, *Cities on the Move* was shown in Vienna, Bordeaux, New York, Humlebæk (Denmark), London, Bangkok, and Helsinki from 1997 to 1999. **3.** At the 1999 Venice Biennale.

Huang Yong Ping, installation, French
Pavilion, Venice Biennale, 1999. Courtesy
Hou Hanru.

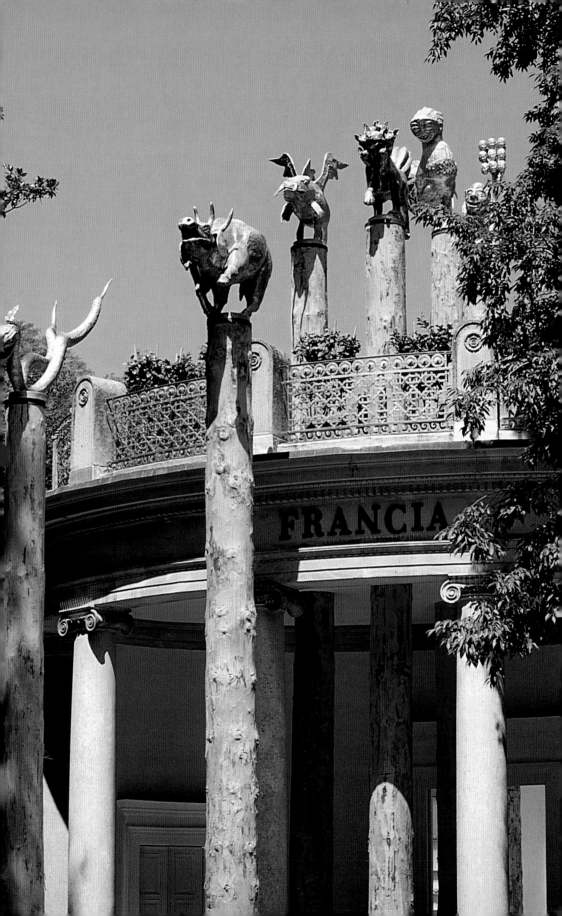

yuko hasegawa
11/2000

In a recent *Flash Art* essay, you wrote, "The fierce individualism and
human rights that distinguish the 20th century will disappear. The main
theme of the 21st century will be to break away from the self and the indi-
vidual and to bid farewell to 19th-century Romanticist social and ideo-
logical ideals."[1] Can you elaborate?

> Yes, there are three elements which have played key roles in the progress
> and development of 20th-century civilization, and each have led to prob-
> lems of overpopulation and pollution: man (or individualism as an atti-
> tude of the modern era), money, and materialism (or capitalism in a glob-
> al economy). New directions in the millennium must be sought to ensure
> spiritual and real-life survival that naturally will lead to the new aspects
> of collectivity: consciousness, intelligence, and eco-existence. In the 21st
> century, we will consider this theme.

Do you see the demise of individualism being replaced by collectivity
as a universal theme, not just an Eastern one?

> I'm speaking from necessity. I don't like to pose this question to Western
> people because they sometimes see it differently. The relationship
> between the individual and the public is another story in the East and has
> inspired my desire to articulate ways in which we can deal with others.

Fancy Dance, your exhibition at the Artsonje Museum in Kwangju and
Seoul, Korea, focused on a new vision of the 21st century. It illustrated
the efforts of the younger generation, exploring its way between tradi-
tion and contemporaneity. Among the contributors was a collective of
artists called Dumb Type.

> Yes, Dumb Type is a Japanese multimedia art group composed of five
> central individuals and six to eight floating members where no individ-
> ual characteristics are manifested. An artistic collaboration would be
> one example, but I am not only talking about the art world. I see people
> trying to connect with each other; through the Internet, for example.
> After we lose the generalities, we still look for a common story, some-
> thing to share. When I speak of a collective consciousness, people
> always think of the psychological context, but that isn't what I mean. For
> me, it means each person thinking independently about new ideas and
> then coming together. A metaphor would be an archipelago: people
> floating on separate islands, but sharing the sea. Another analogy is the
> neural network where there is no center, just connections. Once, when
> people tried to create an artificial intelligence, they envisioned a big
> mother-brain computer assigning missions to the agents. It's a very old
> model. Now we understand that we can't create such a big central brain;

it's technologically impossible. There is a shift to the concept of net-
works; we don't need a big brain, we need relationships.
Yes, there are also groups from the West who have worked in this col-
laborative manner: General Idea from Canada and the Italian group
Oreste. But generally, do you think it is more difficult for Westerners to
collaborate because of our individualistic sensibility?

For Western people the power of the ego, the personality, and individu-
alism is very strong. Japanese people, for example, share conscious-
ness with one another as we are very oriented towards co-existence.
You took the name of your exhibition, *Fancy Dance*, from a popular
Japanese cartoon by Reiko Okano.[2] The protagonist is Youhei Shiono,
who as a Japanese citizen experiences certain elements of fundamental
ambivalence regarding his culture. In the catalogue essay you called it
"an ontological profoundness found in lightness and wit, the coexis-
tence of epicureanism and existentialism as well as the discipline that
is preserved in rituals and forms."[3] Where it is true that much of Western
culture has been absorbed in the East, the Japanese *anime* cartoon form
has become wildly popular in the West: Pokémon, Digimon, Cybersix,
and Princess Mononoke. I am curious about cross-cultural interests, but
I also wonder how these cartoons developed historically.

In Japan, we have a strong history in graphics, of long scroll paintings
that tell a sequential story inch by inch. The style from the *Ukiyo-e* in the
Edo period is one that you might know, since it inspired *Japonisme* in
France in the 18th and 19th centuries.[4] Japanese ceramics were export-
ed to France wrapped in paper with the designs of this period, and the
French, instead of discarding the paper, saved it. After the 19th century
this graphic tradition developed into the contemporary cartoon. But it is
important to understand that the Japanese right/left separations in the
brain have developed differently than in the West. Our right part, which

Left: Yamai No Soshi, *Diseases and
Deformities*, copy, end of Edo Period.
Courtesy Yuko Hasegawa.

Right: *The Princess Mononoke*,
copyright Nibariki/TNDG, Japan.
Courtesy Yuko Hasegawa.

is emotional and visual, is more developed, so the collaboration between
the two is different and our ability to read things from images is better.
In Western brains, the left part, which is more abstract, is stronger.

Perhaps this has become true over time, but aren't you arguing for an unscientific biological determinism?

In Japan, the relationship between words and images is distinct. When you see a Japanese cartoon visual and then link it to the word, you understand that the relationship is very metaphysical, or philosophical. These cartoons carry great meaning for us. This concept of the two brain segments is sophisticated and significant as we are culturally very homogeneous and sometimes our need for communication is so minimal that with one word we communicate a lot. With animation, one frame after another is also an expression of time.

You also speak about "capitalist animism,"[5] where all values are counterbalanced. Can you clarify this?

Capitalism produces many commodities and as a postindustrial country we've integrated animism as it was practiced in ancient times, but with new forms.

Our religion combines concepts from older religions, including nature worship and ancestor worship. Sometimes the animate and inanimate, living and non-living, are the same. The world of Pocket Monsters or Princess Mononoke is closely related to animism. Even today, we somehow believe at the bottom of our consciousness that every lifeless thing has a spirit. Yet where Occidentals find the manifestation of human nature in sculpted human figures, we recognize no human inner nature in cyborgs and robots or in cartoon characters because they are supposed to have a life that is different from humans. In a strange sense, coexistence with these strange beings is congenial.

Your catalogue essay for *Fancy Dance* has many levels of entry. At one point you write, "All the exhibiting artists use the sophisticated methods of the entertainment field. These technical skills create sophisticated metaphysical motifs and it is important that they transcend preconceptions about artistic methods and expressions."[6] Moriko Mori's work has a techno-spiritual sensibility. Is this an example of the animism of which you speak?

Of course.

Does Zen influence your work?

It's hard to describe, but in Zen there is the concept of emptiness. When artists create forms and don't burden them with concepts, there's a

meaning in that void. In a certain respect, it seems to me that Zen is most akin to the essence of contemporary art. As in Zen catechisms, art works only pose questions, and each viewer has to find an answer. Questions appear very simple but answers are of hundreds of varieties and often turn out to be unexpectedly radical. *Furyumonji*, which means "no commitment to writing," is one of the Zen teachings. It means that you cannot explain Zen in words. As Zen reveals spiritual meanings by understanding and action, art should likewise act on intuitive intelligence through its forms instead of illustrating any concept or idea. I esteem those artists who do not stay at the level of self-expression but give up their egocentric concerns and picture the world as visions after this self-annihilation.

Let's pursue the question of the counter-influence. Do you think Eastern countries are losing their uniqueness because of Westernization?

It's the cultural roots… the original way of thinking that's being lost. But the question of originality is difficult to determine. Japanese people always try to make a hybrid in the process of Japanization, and yet they also keep a strong cultural identity. You cannot simply say that the obscuring of originality by Westernization is common. Being an island country in the far East, Japan has been able to keep its cultural traits and is adept at incorporating foreign cultures into its own by style adaptation.

All Asian countries are also influenced. China was culturally isolated by communism but gradually adopted the French deconstructionist theory in the early 80s. This developed into Dadaist, anti-authoritarian, and anti-artistic movements and now the masses are exposed to overwhelming American consumerism. Globalization is going on and artists born in the 70s who have been acquainted with contemporary visual language show signs—with no inferiority to the mainstream—of settling down in the direction of their pursuits and tracing their cultural origins. Although small in number, artists studying abroad are returning home, a favorable case of globalization, which clearly has opened the way for much originality.

You were studying law in Japan but abandoned this in order to study art history in Tokyo. Why did you change?

It was for a few reasons that I changed my course from law to art history. I had a fancy for art since early childhood and my mother was also a modest collector of Japanese art. My father disapproved of my new pursuit so I had to attend all art courses at my own expense. I studied the quattrocento period because I was interested in those primitive forms

that preceded perspective, and the way space and time were expressed
was quite similar to Japanese picture scrolls.

After studying the quattrocento you jumped into the 20th century. What
was your stimulus?

I suddenly encountered contemporary art when Joseph Beuys came to
Japan and lectured at the Tokyo University of Fine Arts and Music. A
friend asked me to help with the communication and as I was unfamiliar
with Beuys or his work, I read as many documents as I could in that short
time prior to his arrival. At the initial meeting, Beuys drew a beautiful
diagram on the blackboard, illustrating the relations between Eastern
and Western thoughts, and for the first time I became aware of the
process in which an attitude or concept takes form. From that point of
meeting Beuys, I changed my course work to contemporary art.

Your exhibition, *Degenderism*, reflects your interest in feminism.

In Japan we have a strange structure. China is seen as a symbol of hyper-
masculinity, and Japanese men have a strong inferiority complex to
Chinese men: feeling very feminine but pretending to be very macho.
It's very pretentious. When I curated the *Degenderism* exhibition, I was
conscious of preceding exhibitions and discourses on gender in Europe
and America in the 1990s and I found something incongruous with my
own views on the reality of the gender issue in Japan.

In Japan, masculinity is frequently displayed ostentatiously as a
form, concealing a twisted inner femininity. Since the age of the ancient
kingdom, Japan, a marginal nation, has always felt inferior toward
China—the huge central masculine power—and it has undergone a dis-
tortion resulting in the display of superiority over Japanese women. For
example, although it is possible to find a chivalrous masculine princi-
ple in the warrior-like *hara-kiri* of Yukio Mishima, you have to discern
his secret femininity in his intensely complex relationship toward the
gigantic masculinity of the West.[7]

I could have focused the exhibition on this matter alone, but instead
I tried to disprove the dogmatic theory of gender and to criticize the use
of an art exhibition for the purpose of illustrating the gender issue. I feel
that art always transcends those analyses and discourses. I gave vari-
ety to the show by putting together Japanese and Chinese artists, as
well as Western artists. The exhibition was intended to convey that our
bodies are a source of highly specific data that define us in society, and
gender is only one piece of information.

Didn't this exhibition meet with criticism from Japanese feminists?

Yes. Most of them claimed that the theory of gender as well as the fem-
inist movement had not yet been rightly understood or firmly implant-
ed in this nation. They demanded to know why I, a woman, would sup-
port a theme that seemed to deconstruct their immaturely cultivated
ideas and that did such harm to their efforts. One viewer observed that
the matter of the body was confused with the gender issue. Another dis-
cussed this exhibition in the same context as typical American feminist
exhibitions. Attacked by these harsh criticisms and mistaken judgments,
I kept on asserting that the exhibition would give no logical answer and
that, after seeing it, people would be free to have different opinions. I
had also been attacked by Western feminists.

Because your work is not theoretically based?

The exhibition was not based on any established theory. Given our dis-
tinct cultures, I have to think about this differently; I cannot just appro-
priate Western gender theory. They say we don't deconstruct society's
conventions; as I see it, we are dealing with these issues, but in a differ-
ent way.

Degenderism was thematically and conceptually intended to escape the
traditional framework and categories of the 20th century, especially in
relation to art practices connected with discussions of gender, identity,
and the body. You write that "in this transitional moment, the beginning
of the 21st century, it is evident that one must ask how to be free of these
prescribed notions."[8]

Gender is a connector. It is one of the most important elements of iden-
tity and, as a social description of our "otherness," it is deeply shroud-
ed in mystery. However, when I say that gender is an important aspect of
the identity issue, I would like you to realize that this is no more than my
own way of viewing this and others interpret it differently. In a 10th-cen-
tury Japanese story, The Tale of Torikaebaya, gender symbols are
exchanged very easily. In a more recent example, Ghost in the Shell,[9] a
cartoon story set in the near future of Japan, the woman protagonist,
who is a cyborg, can dwell in any partner's brain or consciousness.
Finally, giving up her broken female body, she obtains a male body and
is surprised by the strange sensation of excretion. I know that similar
stories and myths are found in the West, but I think that this gender
exchange points to the fact that our view of the framework of human
nature is different from that of the Westerner.

Another reason for focusing attention on gender in this exhibition
lay in the "subjectivity" or "non-objectivity" of the idea. Being either male

Dumb Type, *S/N*, 1993. Courtesy Dumb Type
and Barbara London.

Mariko Mori, *Pure Land*, 1997-98,
glass with photo interlayer. Courtesy
Deitch Projects, New York.

or female, a curator cannot deal with gender from a completely neutral
position. The matter, which could be treated dramatically, politically, humanistically, or in any other manner, was designed to be put forward in a purely vacillating, continuously unsettled condition.

Who were some of the artists you chose and how did their work participate in this concept?

> There were fifteen artists in the show, which presented, in many ways and from different angles, new attempts to connect the body and consciousness. Matthew Barney's photographs, sculptures, and drawings for *Cremaster 1* [1996] refer to a symbolic point from which male or female organs develop in the embryo. The works present images of the indeterminate stage of sex and thematically deal with the creation of a myth or the generative mechanism. Whereas the body manipulated by Barney is based on metabolism, muscle, fat, hormones, and the reproductive process, Eve Hesse's *Ingeminate* [1965], which appears to be two small organs connected by a string, approaches a neural network that requires the connection between the world and body on the level of consciousness or the nervous system. Janine Antoni's *Loving Care* [1993-97] is a drawing she made on the floor by soaking her hair in a dye and moving her body dynamically. Antoni has rightfully inherited bodily performances from feminists in the 1960s and has sublimated them as far more intelligible and refined expressions of the universal issue of identity and body. Mona Hatoum aims to escape from the conventional ideal of the body, a view that may derive from her Middle-Eastern origins. Her *Corps Etranger* [1994-97] discloses the shocking fact that the internal parts of everyone's bodies are strange things; the *others* that are grotesque and monstrous.

You are the curator for the 7th Istanbul Biennial. It is interesting that curators from various countries have been chosen to organize the last four Istanbul Biennials. Paolo Columbo, from Italy, brought language and narrative; Rosa Martínez, from Spain, brought her intelligent and energetic interjection of installations throughout the city; and René Block, from Germany, brought his special sensibility. What will you do?

> I'm very excited about this. Where this Biennial has always had a Western context, I want to bring my Asian background to that environment. Istanbul has a similar history to Japan in terms of being Westernized by European influences. The Western side sees Istanbul as very Asian, and the Asian side sees Istanbul as very Western. There's definitely an ambivalence about the city.

How will you examine this ambivalence curatorially?

It's very simple. I will attempt to answer questions that I've posed for a long time: How can we integrate Eastern wisdom and methodology? How does a *collaboration* of equal sharing and authorship work intellectually? I want to highlight issues of coexistence, humanism, and the sharing of consciousness and egos. Istanbul is very much a multicultural intersection with a high diversity of religions. It's very chaotic and the geographic location gives a significant meaning to this cultural integration.

How will you implement this logistically?

I'll explain the concept to the artists and they will create work that functions within this context. Certainly people will have their own interpretations. In the title word I made up for the Istanbul Biennial, *Egofugal*, I combine the Latin "ego" and "fugal." Fugal, an English adjective for the fugue, is a style of music wherein an original melody is gradually transformed, pursued by its counterparts. The term implies the lightness and rhythm intrinsic to moving away from the ego, transforming itself, just like the fugue. It describes an escape from the center, but it is also about ambivalence: We remain in our own egos and yet try to develop beyond them. By freeing and distancing ourselves from the ego, we may be able to share a common field of consciousness with others. This is different from the conventional definition of selflessness. Here, individuality is valued while respecting others and sharing a magnetic field of consciousness is encouraged. Often we act out of concern for our own ego, especially those artists who create from within themselves. When an artist makes a commitment to the community or society, we have a shifting to the next level and contemporary art can be changed into something else. As I've said, I'm always trying to integrate Eastern and Western sensibilities.

1. Yuko Hasegawa, "Asian Concepts for the 21st Century: Consciousness, Collaboration, and the Possibility of Collective Intelligence," *Flash Art* (March/April 2000), 59. **2.** *Fancy Dance* is a popular comic written and drawn by Reiko Okano, published as a book in 1988. **3.** *Fancy Dance: Contemporary Japanese Art after 1990*, exh. cat. (Kwangju and Seoul, Korea: Artsonje Museum and Artsonje Center, 1999), 14. **4.** *Ukiyo-e* prints were produced during the Japanese Edo period (1615-1867). **5.** *Fancy Dance*, 14. **6.** *Fancy Dance*, 15. **7.** Yukio Mishima, born in 1925, was a highly popular Japanese writer who committed ritual suicide in 1970. **8.** *Degenderism: Document of the Exhibition*, exh. cat. (Tokyo: Setagaya Art Museum, 1999), 26. **9.** *Ghost in the Shell*, a manga by Masamune Shirow, was published as a book in 1991.

Matthew Barney, *Goodyear Field: Cremaster 1*, 1996, *Degenderism* exhibition, Setagaya Museum, Japan. Courtesy Yuko Hasegawa.

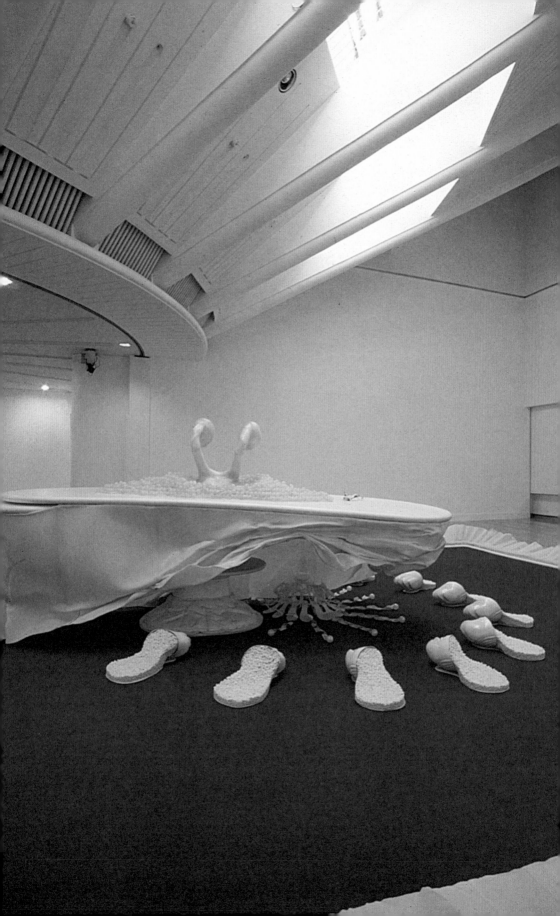

vasif kortun
09/1999

In 1992, you were the curator for the third Istanbul Biennial, then you moved to the United States and now you've returned to Istanbul. What motivated your return home?

I missed Istanbul and wanted to start the Istanbul Contemporary Art Project center. I started this in 1998 after returning from my work at the Bard Center for Curatorial Studies.[1] This Istanbul project center now maintains the archives of almost 40 contemporary artists from Turkey. We have a "research" wing and a small library, and international periodicals arrive each month. The research is based on maintaining some memory of contemporary art in all of Turkey. One aspect of this is to archive the present day, but also to look at the past to see what we can salvage. For example, we have an oral history project where we interview artists who are not on the commercial circuit.

Does the archive also include works by international contemporary artists? Where do you draw your line?

There are a couple of lines. Firstly, our critical moment is 1968. The older generation of artists was in school around that time. The oral history project records that moment, answering questions such as: What were they looking at? What was the publishing situation? Who were they reading? Who were the writers they spoke to? What films did they watch? What groups were being formed? And we also take it from 1968 to 1987, which is the year of the first Biennial in Istanbul.

Who curated that Biennial?

Beral Madra. She did the first two, but those were not "curatorial" projects.

What was the stimulus for Beral to do an international-scale exhibition?

The Biennial was the product of a momentum from a series of exhibitions cropping up. The Foundation for Culture and Art, which is the mother organization behind the Biennial, had already been incorporating exhibitions into its various other activities. The Biennial was part of this branching out; it was their initiative. When students graduate from school today they don't know this past, so our idea is to turn this research into a publication that would chart the changes. The Biennial was an international show, but not so precise.

What do you mean?

It was a series of divided exhibitions that followed the general model of contemporary art in historic sites and blue-chip artists: the ones in historical

towns, especially Hagia Eireni, the Yerebatan Cistern, the gates of Hagia Sophia. Those parts of the exhibition were the real international parts.

Did Beral have a committee or did she invite the artists herself?

There was a committee, but the exhibition could not have been done without her. She became the de facto curator.

Did these Biennials get international recognition?

Progressively more each time. The first one in 1987 didn't get so much attention, but it improved in 1989. In 1992, the confirmation/legitimization by the international press was enormous. This is the one I curated.[2]

By what process were you chosen to curate the Biennial?

The foundation decided to go with a new person. At that time the local reaction to an international exhibition was stronger than now. There was a provincial market with its products and collectors. Local powers were much stronger, you see. Beral was chastised, as I would be later on. That was the late 80s and many dictatorships were dying or fading away, mutating into neo-liberal political systems. There was a lot of money around and a boom in provincial collections. The Biennial intervened in this social space and problematized it, even though it had been an agent of the neo-liberal economy!

I imagine that the international work was threatening to the art culture of Istanbul?

When you're in an isolated place with only local truths prevailing, things are pretty harmonious. Then the walls start to come down and suddenly new work, culture, and new visual proposals flood the situation. The Biennial naturally becomes a threat.

Has the international work taken over?

Well, I don't really know what international means, but the possible lan-

Left: Selim Birsel, Untitled, 1991-92,
installation view, Istanbul Biennial. Courtesy
the artist. Photo: Vasif Kortun.

Right: Hakan Onur, *Merry-Go-Round*,
1991-2, installation view, Istanbul Biennial.
Courtesy the artist. Photo: Vasif Kortun.

guages of contemporary art are more available now. Of course, it was not only the Biennial that had new proposals. Sarkis' *Caylak Sokak* installation in February 1986 at the Macka Art Gallery was a major signal of change.

Tell me about this.

Well, Sarkis had been living and working abroad since the end of the 1960s, but he never had a one-person show in Istanbul, nor was there a context for his work. At the same time he was Turkey's only internationally known artist. Other artists lived abroad, too, but most of them only showed and sold in Turkey. So, when Sarkis did this critical installation, which was later reconfigured for the *Magiciens de la Terre*,[3] it became an intervention in the closed, provincial cultural circuit of Istanbul. Now, it was certainly not the first contemporary art exhibition here, but Sarkis amplified its significance; the work was a constellation of memories of his childhood with a precise local gravity. Some isolationist locals hit back for a few years with a smear campaign saying that Sarkis was an Armenian sympathizer, "a dagger in our loins." In retrospect, that chapter in the history of contemporary art in Turkey was all about xenophobia. Contemporary was alien, folks like me were aliens, the Biennial was alien. The thing is that this modern, elitist, provincial mafia used to think they were in the same league, but they're not. It's like the galleries on West Broadway in New York, which sell these things called "art" to gullible tourists.

Tourist art as opposed to....

As opposed to contemporary art. At one time, the two were indistinguishable. But this was not a situation specific to Turkey alone.

The confusion resulting from the recent explosion of information is not only Internet-related, but also relates to the demise of the Communist structure and the opening of borders. Geo-politics have been drastically altered and now we are obliged to confront the social, personal, and political residue of that change. How is this manifested in the art that is shown in Istanbul exhibitions?

I guess there wasn't the clarity of this division in either of the first two Biennials. There had to be more compromises as to what was contemporary and modern and so forth.

Istanbul is situated in a strategic geographic position. At the crossroads between East and West, it is physically divided by the Bosporus, between Asia and Europe.

Yes, geographically divided, but not mentally. These terms don't make so much sense in Istanbul, because we cross continents daily. The Bosporus Strait also separates the North and South, the Black Sea and the Aegean. This is something often overlooked. Therefore, Turkey is also between the Slavic and the Mediterranean climates. I think this aspect is at least as important as the East/West situation.

The Russians didn't have access to the Mediterranean unless they traveled through the Bosporus, so Turkey has always been in a vital position. Tell me about the influence of Istanbul's geography on the Biennial.

When I did the third Biennial I wanted to be treated equally. There's a French term, *"bon pour l'Orient,"* or "good enough for the Orient." I didn't want that attitude. That was fundamental. Second, I didn't want to use historical sites for exhibitions because they serve a touristic mindset. The historical town, the Theodosian city, is not where the people of the city go. I was very tired of this idea of contemporary art in historical sites, since it was overdone all over Europe. I had to re-orient the intellectual position of Istanbul. For example, Turkey's proximity to the Balkans and the North used to be overlooked by the vertical order of culture. Under bureaucratic Socialism, there was a wall between us, but we had so much shared past. I felt that the Biennial must take account of the Balkans and Russians, and also the reality of the city, which was at that time full of Rumanians and Bulgarians. They came here in the logic of an underground barter economy, bringing things in their suitcases. This must have its intellectual counterpart, I believed. So, we included Rumania, Bulgaria, and Russia. We tried to include Slovakia. And with the war just beginning in Sarajevo, Bosnia was negotiated but was not possible.

How did you go about choosing the artists for the 1992 Biennial?

I didn't have the budget or the knowledge to curate the whole exhibition myself. I also didn't want the Cairo/Venice model with national pavilions. The nation-based proposal was not what I was after, yet I didn't have the funds to do what I really wanted. As a curator living in Turkey, I didn't have the audacity to fly all over the globe and bring everything here, as I don't believe one can understand a country in a three-day visit. So I went to artists and curators and tried to build a community of understanding. These people were great, and I became a conduit. The overall theme was "the production of cultural difference."

This exhibition played a significant role in devel-
oping an understanding of globalism.

Yes. I had seen *Magiciens de la Terre*, and had been following other proj-
ects like the *Decade Show*,[4] and either peeking in on or participating in
a series of conferences that were formative for me. But *Magiciens* was
decisive—the first major post-colonialist exhibition I knew of at the time.
It had a lot of flaws, but was a beautiful failure nevertheless.

To what do you attribute its failure?

The logic of the selection process. You know, not all cultural translators
in the so-called Third World are colonialists, self-colonizing agents, or
culturally dominant elites. There are people you can trust. They totally
overlooked this fact. As if post-colonial thinking can only be perceived by
Europeans and Americans! Secondly, they chose all their magician "oth-
ers" from non-urban situations or paradigms. Hey, the so-called Third
World is the new urbanism!

Was the work of urban cultures contaminated by
modernist principles, and thus considered inau-
thentic to the country? Or were Jean-Hubert
Martin's choices simply post-colonial?

I think they led themselves to believe that all the work of urban cultures
is contaminated by modernist principles. So the real thing would have to
be closer to the less urbane. Fantastic, no? You posit a singular mod-
ernism first, and allow no deviation or other modernisms. It is the good
old authorship.

Coming back to my Biennial, after the contacts and deep discussions
with, let's say, the non-institutionalized, non-governmentally related
agents/curators, we constructed these parts of the show very precisely.
The idea was to establish the situation first, then find the money for it.

Was that difficult?

It worked to an extent. Rumania, Bulgaria, and Russia came up with bril-
liant proposals that made a lot of sense within the Biennial. The exhibi-
tion was situated on one site of about 5,000 sq m with about 72 artists.
We created porous wall setups so that there would be visibility from one
country to the next, and you could see through from one section to
another. The additional idea was to create an installation plan so that,
as in Istanbul itself, the visitor would constantly turn corners until he or
she lost the sense of East or West, North and South. I wanted to do away
with this touristic orientation. We did the exhibition design with Mehmet
Dogu, a Princeton graduate. But the architect for the restoration of the

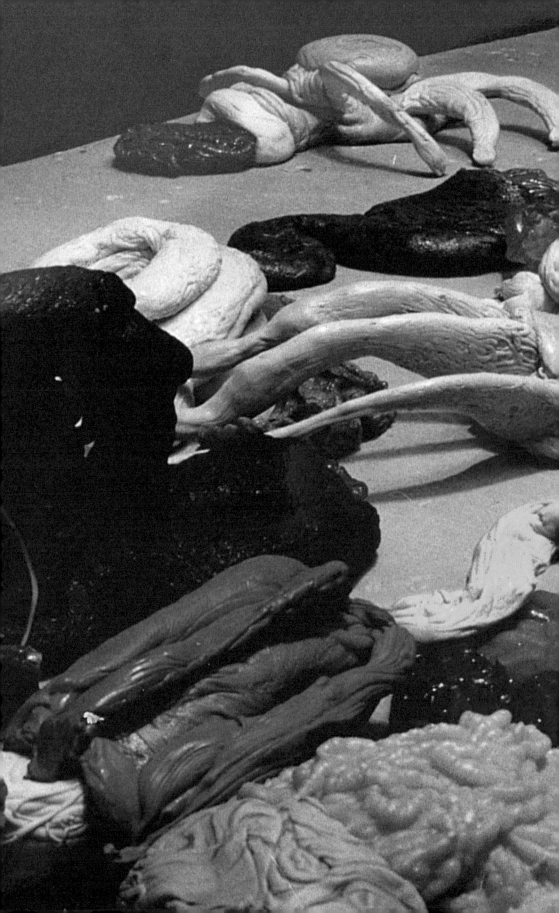

building, Gae Aulenti, wanted to show "her building," and cut an artery through it like Mussolini cut through Rome.

> Did René Block, the curator of the following exhibition, use the same format for his Biennial?

René took the next step and eliminated the national idea. He chose artists, not countries.

> Did certain countries feel they were lacking representation?

Of course, there's always that possibility. But an exhibition is about the chemistry and the openness of the curator. It is not only about singular works but also about a climate in which they exist. You can't have it all.

> For the first three Biennials in Turkey, there were Turkish curators. Why are curators now chosen from other countries?

Well, I'm not on the selection committee. But I don't believe that international shows must have national curators because of where they take place. Different people provide different visions potentially overlooked by someone who lives here.

> If they asked you to curate the next Biennial, how would you handle it?

[Laughs] I couldn't do it. I don't think I can speak on behalf of the whole globe, or even claim to understand it. Then, when you have professionals representing different parts of the globe, it can become a boring assemblage. What I would do is change the structure completely, spread it to two years, do smaller projects, tie those to the city and its institutions, stress informal educational programs, and emphasize different modalities of cooperation and visual intervention.

> There are many of the same artists in these gigantic international exhibitions now.

That's the International Biennial Syndrome.

> From what you said, it's impossible to go around and choose, and some biennials appoint commissioners who go to different places to choose. This was the case in Johannesburg and in Kwangju.

Yes, but this has relative success. For the 1998 Biennial in São Paulo, I was a co-curator for the Middle East for the *Roteiros* (*Routes*) section, connoting the seven parts of the world. But we didn't find the right connectivity between us, despite the good will of the Chief Curator, Paolo Herkenhoff.

Maybe biennials should pose questions, not
answers. They are for explorations and dialogue.
There are many problems with biennials. They're easy grounds for professionals; like tourists, you hop from show to show, see the same people. It's not working. There are also political problems. They are too easy.

Biennials don't change the state of human rights in host cities.

Yes, it's the pleasant face, the nice, good, tourist-friendly face of those towns that biennials can open; but they are also concealing.

But if a city is exposed, then less can be concealed.

It is an issue of the mechanisms of opening, and delicately designed forms of censorship. Turks get very nasty when their country or mentality gets criticized. It's like taking one on a walk in the city when it is pitch dark. I would like to see all of you in Istanbul when there is not a biennial.

Geography and funding make that difficult. You worked for the Bard Center for Curatorial Studies in its infant stage.

Yes, it was the first accredited curatorial program in the States. I worked with Norton Batkin, who was (and is) the Director of this program at Bard. I ran the exhibitions program, library, and museum matters. There was a linkage between the two. It works quite well. After four years I left, burnt out from fund-raising and administration. I had my eye on returning to Istanbul and I needed to be closer to artists and to start an institution.

Tell me about ICAP.

The Istanbul Contemporary Art Project is a super-low-maintenance, volunteer-based place. We publish a magazine. The important thing for me, at this time, was not to have an exhibition hall. I don't do exhibitions when I'm not convinced. I've only done shows when there is a problem that interests me. I'm unprofessional that way. Once I'm concerned about something, then I can do it, but often when I'm invited to do something I think it's a flop.

Have you curated many shows since you've returned to Istanbul?

A few. One was in an office, with 28 artists. It was called *One Special Day*. Like a journal, the artists had to do their work on September 1, an arbitrary day. There were four parts to the exhibition: text, audio, things you can carry, and images. But I also asked each artist to move out of his or her everyday style.

Do you feel as if you've made a difference in
Istanbul? Was there an arts center here before?

We are not an arts center, but there are centers that I don't have any respect for. The issue of change is not one I can speak to. My position is different because I work intimately with artists—so much so that I sometimes feel I can intervene in the production of the work.

Editing or collaborating?

If you see a work that is growing toward something, then you want to get involved in the process. I am not good at collaborating. I don't have ideas; I only see ideas and build upon them.

Give me an example of how you create a show. What is your process?

No two shows are alike, so there is no knowable process for me. I don't believe in a singular position. The starting point is always different; the motivations are diverse; the level of curatorial involvement varies; so does your understanding of sharing responsibility. When I was at the Institute of Fine Arts, at NYU, for graduate work, a rather well-known professor and curator said, "Don't trust the artist." The reverse is my motto. For me it's always about inventing new modalities for looking at things. The worst thing is repetition.

1. The Center for Curatorial Studies is at Bard College in Annandale-on-Hudson, New York. **2.** The 3rd Istanbul Biennial, directed by Vasif Kortun in 1992, was entitled *Production of Cultural Difference*. **3.** *Magiciens de la Terre*, organized by Jean-Hubert Martin, was shown in 1989 in Paris at the Grande Halle at the Parc de la Villette and the Centre Pompidou. **4.** *The Decade Show: Frameworks of Identity in the 1980s*, organized by Julia Herzberg, Sharon Patton, Gary Sangster, and Laura Trippi, took place in 1990 at the New Museum of Contemporary Art, New York (co-organized by and presented with the Museum of Contemporary Hispanic Art and The Studio Museum in Harlem).

Gulsun Karamustafa, *Mystic Transport*, 1991-2, installation view, Istanbul Biennial. Courtesy the artist. Photo: Gulsun Karamustafa.

mária hlavajová
03/1999 and 11/2000

With four curators from different countries who
don't know each other, and who presumably have
styles and ideas that differ, how will *Manifesta 3*
operate as a collaborative process?[1]

We are in a very early stage, so it's difficult for me to speak about this.

Is there a specific guiding principle for *Manifesta*?

No, there is nothing prescribed. *Manifesta* is a European biennial that is
redefined each second year and there are very few parameters. However,
it ought to be a biennial of young art; again, without a definition of what
young actually is. It's for the team of curators to decide whatever phan-
tasmagoric category to attach to this.

How do you define "young art?"

Manifesta will be an exhibition for artists with interesting artistic posi-
tions who are not yet established on the international scene. Yes, one
could be "young" in this sense at 65. So for a curator to find young artists
here requires profiled research through studios and other primary meth-
ods. In Eastern Europe, where the gallery system is not comparable to
that in the West, the partners for this research are the locally based cura-
tors, critics, and art historians who can guide one to artists' studios.

You are the only Slovakian on the curatorial team,
so the search, at least within Eastern Europe, will
be easier for you. How will the other curators
choose artists?

The issue of cooperating with others is certainly challenging, but it also
provides an opportunity to subvert the notion of a strong individual cura-
tor. We certainly hope that final selections will be done by consensus.
Recently, at a panel at the Goethe Institut in New York, we had a discus-
sion about "curatorial tourism"—about curators trying to understand
local artists in their context within half a day. The way to avoid this situ-
ation is to involve more local people in the cooperative process.

With little contextual involvement, some major
exhibitions are like plants under glass. Will
Manifesta 3 attempt to create an interface?

My meditation for the Goethe panel was about contextual relations. There
are so many curators running from one country to another in short periods
of time. They cannot possibly understand the context in which the art is
being produced. You either decide to neutralize the context, to ignore it
and choose artists from your own limited perspective, or you build a struc-
ture for transferring knowledge from the local landscape and trust the ones

who, in the context, are well aware of the developments and tensions.

Ljubljana, the capital of Slovenia, is a new place in an old Europe. It is on the brink of participation in the European Union; geographically, it is close to ethnic struggles, yet has the pace of a small international city.

Moreover, it has a lively art scene and a good infrastructure of art institutions, supported by great thinkers with a serious involvement in contemporary philosophic discourse.

The politics of this region have been bloody. Does this come across in the work?

One of the curators of a past *Manifesta*, Robert Fleck,[2] referred to the question of why young artists in Yugoslavia do not explicitly deal with the issue of war. The answer is complex. The younger generation of artists entering the art scene after the political changes in 1989 often consciously tried to articulate themselves within an international discourse of meaning beyond their own locale. Discussing the war in Yugoslavia could locate them in the Yugoslav context. The generation of artists who entered the art scene in the 90s had attitudes toward reality at large which were very diverse, with ideas that involved individual mythologies, biographies, and social networks. I think their aversion to ideology is the toll of having been forced close to ideology by totalitarian regimes. I've heard many say, "We do not want to be looked at as Yugoslav artists; we want to be seen as artists."

There is a real need to rethink exhibitions so that they respond to a specific social environment.

I cannot speak for other exhibitions. *Manifesta* is a child of the post-Cold War situation. We are told to believe that there are no borders anymore, and there's a new Europe. Although the map and the politics of Europe have changed in the last ten years, a "wall" still exists. Now there is a need to discuss how different parts of Europe can communicate, if at all. So the base of *Manifesta* was to see what was happening in these parts of Europe, knowing there are many centers of artistic activity.

Although I would like to forget the East/West polarization in discussions of Europe, there is one issue connected to the history of *Manifesta* that needs to be researched: the notion of "international style." Robert Fleck said that there was no longer an alternative social model to capitalism or to global visual culture, which in my understanding means that Western art won the battle. On the one hand, it is an acknowledgment of the similarities between Eastern and Western art production in

Europe. On the other, it's an articulation of the supremacy of Western language in the arts.

But doesn't the reality of the present situation require you to reclaim it?

We will try.

11/2000 In our previous talk, I remember that you were discussing how few younger artists in Eastern Europe deal explicitly with the residual effects of contemporary politics in their work. And yet, as you know, *Manifesta 3* was fully dedicated to these kinds of discussions through art works.

Yes, you may see a big shift in my mind about what's going on in European art—before and after my research. I began to feel frustrated with the composition of many international shows, which were somewhat interesting, but looked a lot alike because they often exhibited the same artists. And then I was invited to join this team and co-curate another international exhibition. The four curators met in Ljubljana, just a couple hundred kilometers from where war was happening at that time, in March 1999. It seemed rather ridiculous to spend money just on an exhibition showing art works and satisfying curatorial egos; it was quite a large amount of money for that region of the world.

What was the budget for this project?

The budget was ridiculous by American standards.

And by other biennial standards as well?

For that part of the world, the East, $1 million was a huge amount of money, but by Venice or Lyon standards, it was small. This money could have been used for something much more useful, I thought.

Did you think that the exhibition was a frivolity?

Ene-Liis Semper, *FF/REW*, 1998, video still. Courtesy Maria Hlavajova.

At that point it was a weird feeling. It urged us to ground our effort in the
contemporary reality of the region. We chose the title, *Borderline
Syndrome—Energies of Defense*, which we borrowed from the field of
psychology. It seemed appropriate as issues of identity diffusion,
defense mechanisms, protection, and resistance have shaped a num-
ber of recent artistic, geopolitical, social, and personal events. Slovenia
had its own borderline qualities. For me, coming from the East, there
was something "West" about it. Ljubljana was the place where I went to
buy my first blue jeans, the ultimate sign of Western society. When I was
younger, we thought of Ljubljana and the Yugoslav Republic as if they
were the West, even though Western Europe considered them the East.
It already had a dual identity. At the time of our initial discussions about
Manifesta 3, we wanted to base the exhibition's title on an issue derived
from the local atmosphere of Slovenia and Ljubljana, but also one that
has meaning for the whole of Europe.

In the introduction to the book *Post-Theory, Games,
and Discursive Resistance: The Bulgarian Case*,[3]
Alexander Kiossev talks about the lost context
after the Wall came down—how political aesthet-
ics after Communism dealt with the destruction
of the Wall's potential to construct meaning, leav-
ing behind not only an intellectual but a corporeal
void. Kiossev writes about the pathos of that col-
lapse of ideas and sensibility—how one fills in the
past, present, and future becomes complicated
and disorienting. He also raises the issue of immi-
gration, the displacement of people as a result of
war, and how the West—with its capitalist econ-
omy—considers them an economic burden.

Alexander Kiossev heavily informed my understanding of what the exhi-
bition could become. An essay I came across in the book about the
Bulgarian avant-garde talks about something very significant. That is,
what happened to the intellectuals in Central and Eastern Europe? How
do you relate that huge intellectual potential to current political devel-
opments when the country is moving towards nationalism or ultra-right
thinking? This can probably be translated as a vote against globalism.

Why?

This was true about Serbia, Slovakia, Croatia, and it's still the case in Belarus.
Kiossev seems to be saying that the project of nationalism is the project of

intellectuals, who, since the political change, have found themselves humil-
iated in their cultural context, looked down upon as secondary citizens.

As peripheral to the larger context of Western
intellectual discourse?

Well, I wouldn't talk about the Eastern Europeans as peripheral. I would
rather talk about a semi-periphery. It's interesting, what you were say-
ing earlier. Art coming from that part of the world is very different, it
seems to be resistant to ideas of globalism in art. The contemporary art
practice in Central and Eastern Europe had different economic possi-
bilities, and I still believe there's a very different intellectual atmosphere
in which artists are working. It sounds problematic, but I had the expe-
rience during my research that the most dynamic and active art scenes
were often in countries that were very poor, where artists didn't have
supportive infrastructure like galleries or governmental subsidies. For
instance, Albania has an interesting art scene, despite dramatic politi-
cal and economic circumstances.

Who are some of the artists?

Anri Sala, for one, made a video that consisted of two stories: one of a
man who had thousands of fish in an aquarium and the other of killing
people. We were forced to see the two narratives as intertwined.

This illustrates a "schizophrenia" that exists in
that part of the world, a consequence of being
subjected to the Borderline Syndrome.[4] How
does Maja Bajević's work elaborate this theme?

She comes from Bosnia and Herzegovina, another country on this list
where there's minimal infrastructure and support given to artists, and yet
where the art scene is extremely interesting. Her piece, rooted in the local
context of Sarajevo, is a video of a five-day action, which occurred during
the reconstruction of the National Gallery. Maja invited women from the
refugee camps to show their handicraft and skills by embroidering the
outer curtain that surrounds the building while it is being reconstruct-
ed. It's a very romantic and subtle piece in this sense, but also a power-
ful social statement—something that can be analyzed in a few ways: in
terms of the concept of relational aesthetics among these women; as an
intelligent remark on the political and financial post-war situation in
Bosnia and Herzegovina; and as a subtle critique of institutions.

Why was it that much of the work in *Manifesta*
was neither large nor visually seductive?

This corresponded finally with the decision of the curators. While talking

about very serious political and social issues we did not see much room
for spectacular or megalomaniacal installations.

> The problems inherent to a Borderline Syndrome conceptually present a negative spectacle. Furthermore, it adds visually and conceptually to have big and small. Perhaps it was a curatorial mistake to keep all the works low-key.

I believe this kind of subject allows for deeply conceptual strategies in works of quiet gestures. That's what we opted for. We hoped the narrative would hold the exhibition, rather than the spectacle.

> But of course there were many poetic and negative spectacles in the show. One, by Ene-Liis Semper, was a quietly startling video depicting the preparation of a suicide. Did this issue of spectacle enter the collaborative discussion?

Issues of spectacle were brought into our discussion many times. This was part of our curatorial controversy. It was Ole Bouman, who works in the field of architecture and probably encounters bigger budgetary opportunities and different dynamics of cultural production, who many times called for spectacle. Francesco Bonami had a different position: As a museum curator he focuses less on spectacle but on photography, painting, and classic sculpture. As the curatorial process was underway we had gathered a lot of quiet, gestural pieces and at that point, one strong spectacle could swallow the whole show. There was one challenge I'll always remember and that's about the ideology of consensus. How do you curate an exhibition in a team that bases its collaboration on ultimate consensus regarding art works?

> Isn't this the way *documenta* is presently being organized?

The structure of *documenta* is very different and, so far, rather hierarchical, I believe. Once an artistic director is appointed, then he or she chooses a team with which to work—people with whom he or she gets along. In *Manifesta* there's an international board that views the work of young curators and chooses among them for the team. So one nice morning you get a call to see if you're interested, even before knowing who your collaborators are. All have equal rights and responsibilities—there is no hierarchy. Automatically this creates a difficult situation for the group's psychology. Unless you have had enough time and political acumen to invent collaborative strategies, this creates difficult and heavy

Previous two pages: Maja Bajević, *Women at Work*, 1999, SCCA Third Annual Exhibition *Under Construction*, National Gallery of Bosnia-Herzegovina, Sarajevo. Courtesy Sarajevo Center for Contemporary Arts. Photo: Mariana Curic.

group dynamics and psychological situations.

Did it become a personal barter situation?

Very unfortunate, but yes. If you have a different point of view in terms of understanding contemporary art practice, it is difficult to persuade your colleagues that your way is right.

It sounds as if consensus is not the way to go when working in collaboration. But what about the method used in the Kwangju Biennial, with five different commissioners, each choosing art from his or her assigned portion of the world?

It's a possibility. We believed in the beginning that we wanted to share authorship. We thought if we divided territories, which is a rather colonialist attitude in my opinion, you would see four different exhibitions running parallel. We wanted to avoid this division and we did. And in the end, I really don't think that even anyone who knows my curatorial practice could identify the art that I brought in.

Perhaps not…the aesthetic was pretty homogenized.

I think the curatorial disagreements were worth it in the end. I call it a productive "dissensus."

The artists dealt with the contemporary politics and aesthetics of Eastern Europe that referenced Kernberg's categories of the dysfunctional personality. Sisley Xhafa's work is about migrations, illegalities, immigrations, and multiculturalism, for example.

He did a performance at the railway station in Ljubljana once or twice. He learned the gestures of stockbrokers, which are supposed to be a pretty international language that one could "expect" people all over to understand. He used this language to announce departures and arrivals of trains at the station. Of course it was an inappropriate context. But you can see it as a metaphor when we discuss an international language of art nowadays.

In some of his writings on Social Sculpture, Joseph Beuys referred to the great wave of immigrants, the bearers of different values and new truths that the West must recognize if it is not to collapse. He could have been describing the current situation in Europe when he discussed the problems

multicultural immigration brought to Eurasia. Today, culture implies the capacity to transform. Does Sisley Xhafa's work challenge this?

Absolutely. There are many readings of this piece, but what's interesting is setting up an inappropriate context where an "international" language is not being understood, which might be a metaphor for current art strategies. You don't have to play safe games by constantly using certain language in visual art.

What about language and text as illustrated in the work of the artist Boris Ondreicka, with whom you have worked extensively?

Boris lives in Bratislava. He uses the English language and text as part of his installations. His written manifestos and lectures about his work are the performances. He enlists a specific form of the English language that might be considered "Eastern European English." We have not really learned proper English in school, so I can understand it, but native English or American people would not.

His essays in the catalogue are almost impossible to read, but you can understand them somewhat by reading the text aloud. English is the second language that is often spoken in many countries. Is there some equivocation about its use?

English is an absolute necessity, no doubt about it. It's the Esperanto of our time. There was, in the late 19th century, a utopian desire to create an artificial language for universal communication and understanding. It was not actually spoken in any country but all were expected to learn it in order to communicate. It was acknowledged theoretically, but failed in practice.

Talking about language, two works at *Manifesta 3* were particularly important to me because of their silent yet strong articulation. Many

Left: Roman Ondák, *Antinomads*, 2000, set of 12 postcards. Courtesy the artist.

Right: Sisley Xhafa, *Stock Exchange*, 2000, performance at *Manifesta 3*, Ljubljana, Slovenia. Courtesy Laura Pecci Gallery, Milan.

people didn't even notice them because they were very fragile in form, but they were instrumental to the exhibition. One was the piece by the Polish artist, Paweł Althamer, who arranged a team of eleven amateur and professional actors who, each day at 4:30, performed in the Main Square in Ljubljana. The piece was called *The Motion Picture*. It was a very ordinary performance with a clear, well-scripted scenario, although as a passerby you wouldn't know they were acting. It contained, among other things, a kissing couple, a man playing the bassoon, a homeless man, and another man on in-line skates. I've spent many afternoons there and I think it was a great spectacle, and very individual.

Well, what made it noticeable as a piece of art? Only that at 5:00 they got up and left the stage at once, after having performed for 30 minutes. The viewers were able to read the script, but once they saw two couples kissing, they could wonder who was acting and who was not.

Roman Ondák is another interesting artist from Slovakia. His work of second-hand images of tourist sites, called *Antinomads*, evolves from his storytelling and the residue of objects and drawings left by the different individuals who translate his travel descriptions. After returning from a trip, Ondák would describe what he had seen on his travels to people who never travel. He then instructed them to visualize their own conceptions of those people, places, and stories. So someone who never saw the Eiffel Tower creates it according to his own ability and imagination. Thinking about his project is somehow bringing me back to memories connected to *Manifesta* that seem very long ago. "We don't plan our memories," Ondák says in the *Manifesta 3* catalogue. "But this time it will be different." He continues articulating the intensely lived years of this project: "I'll be pursued by this idea of remembering. Maybe I'll want to see things that otherwise I'd neither want nor need to see."

1. The curators for *Manifesta 3 (Borderline Syndrome—Energies of Defense*, Ljubljana, Slovenia, 2000) were Francesco Bonami, Ole Bouman, Mária Hlavajová, and Kathrin Rhomberg. **2.** Robert Fleck, with Maria Lind and Barbara Vanderlinden, co-organized *Manifesta 2* in 1998 in Luxembourg. **3.** Alexander Kiossev, ed., *Post-theory, Games, and Discursive Resistance: The Bulgarian Case* (Albany: State University of New York Press, 1995). **4.** Borderline Syndrome is a term borrowed from Otto F. Kernberg's book on borderline disorders, *Borderline Conditions and Pathological Narcissism* (New York: J. Aronson, 1975).

rosa martínez
02 / 1999

In the publication *Cream*, you said, "The practice of being a curator gives you a chance to work in dialogue with the artist to co-produce a new reality and to relate together in a new context."[1] Can you elaborate?

> When I organize an exhibition my first step is always to define a conceptual framework. The conceptual framework is based on a series of updated reflections on the problems of contemporary life and art that correspond to a larger cultural framework. I then start thinking about artists and specific works. I might select an existing piece that an artist has produced because it connects to my concept. In other cases, a work may be site-specific in relation to my proposal, a city, a context, or a situation; in still others, the artist may create an entirely new project. I like to create a common ground of understanding and, after exchanging ideas, to negotiate and feel a full communication and an enthusiastic agreement to develop the project.

Many curators work with a consistent nucleus of artists. How do you find new artists?

> I am informed through many sources. My research is a continuous and open process. I travel, visit exhibitions, and read the magazines and catalogues for shows that I don't see personally. I exchange ideas with other curators. Artists are a good resource about other artists. Philosophy and cultural theory are also components that fuel my interpretations. Artists who reflect the moment and who go beyond accepted conceptual and formal disciplines are my choice. For example, I believe painting has elaborated a historically important discourse and has strong meaning, yet in the context of a biennial, which looks beyond the present and into the future, the discipline of painting is unrenovated. Video and photography are renovating painting.

Can you define the role of the biennial vis-à-vis the museum?

> Biennials are transgenerational and transnational and describe newly interconnected strategies. The discourse that separates is over, and while the barriers are toppling, the artist's multiple modes of expression must be exhibited. Biennials are the most advanced arena for this expanded field precisely because they do not function like museums. Museums are temples for the preservation of memory where the art works are fetishized and displayed to create reverence and distance.

In Dennis Oppenheim's 1971 work, *Protection*, he blocked the entrance to the Metropolitan Museum with guard dogs to question the sanctity of museums. Today, structures have changed and museums contain project rooms for contemporary installations that are less precious than what you describe.

I am an art historian. I appreciate all moments in art and I defend the existence of the museum. Museums are rarefied sometimes but they are also trying to renovate their strategies. Today, however, biennials are a context for the exploration and questioning of the synchronicity of the present on both a global and an intergenerational level, while also presenting an opportunity to break through the centers, like New York and London. The centers have the power, but those on the periphery have voices that contribute to a better understanding of our world.

The early model for the biennial was Venice. It was a Eurocentric, nationalistic model born of the 19th century, where each country had its own pavilion like an embassy or trade show.

In 1980 Harald Szeemann questioned this territorial separation by founding this new section, the *Aperto*, for young artists at the Venice Biennale. *Aperto* artists represented their art, not their nation. However, the model was canceled by Jean Clair, a subsequent Biennale curator, who said, "The young ones, we don't need them." Szeemann, now in his mid-sixties, is a perspicacious, generous, and fantastic man. It is fitting that he has been chosen to be the curator for the next two Venice Biennali, in 1999 and 2001. He calls these "turn-of-the-millennium Biennali": "*Aperto* All Over," so the new spirit is clear.

It is also true that cultural politics employ biennials to enrich the local atmosphere by way of a tourist attraction. This is a way for a city to move into a new economy… not a bad thing, really.

There are so many places on the planet where international discourse

Cai Guo Qiang, *The Other Shore*, 1997.
Courtesy Istanbul Biennial.

Greenpeace, 1997 action against genetically
engineered soya, Turku, Finland. Courtesy
Istanbul Biennial.

can be questioned and improved. This widened dialogue doesn't always
have to happen in the centers; all places contribute to an understanding
of certain realities today. Istanbul has 15 million inhabitants and Santa Fe
has only 55,000, but the dialogue that has begun is a contribution and
is necessary.

Santa Fe is a small, complicated city, rich in contrasts and symbolically
close to the end of the world. Here, a naturally flamboyant landscape of
mountains and high desert also contains the bleak reminder of the
Manhattan Project.

Looking for a Place, my title for SITE Santa Fe,[2] questions the place that
art has in our societies today as well as the notion of finding one's own
place. How we conceive natural places like the ocean or the desert, how
we experience our bodies, and how the politics of space are sexually
organized are all elements of this. The answers are different in each
locale, but they might have similarities, too. Santa Fe is a perfect envi-
ronment in which to present an exhibition aimed at a fruitful dialogue
with contemporary international art currents, and one that speaks to
finding one's own place. Sometimes it takes a long time to find one's
place. It took Walter De Maria five years to find the place to install
Lightning Field [1971-77].

What do you extrapolate from the diversity of cultures in Santa Fe?

There are three communities not living together or interacting much:
white Anglo-Saxon, Hispanic, and Native American. In this one place,
all of the problems of identity, struggles for land, thematic tourism, sci-
ence, and nature arise.

Will the nature and culture dialogue be addressed in SITE Santa Fe?

I have been to Santa Fe with some of the artists, who have explored the
place and thought of different projects. We have discussed them, trying
to connect understandings and find a common direction. As the cura-
tor, I have an overview of the show's content and appearance. I don't
think artists are just producers of things; they project their own under-
standing of the world and I respect that. I've invited Cai Guo Qiang, a
Chinese artist who made a project in Hiroshima with gunpowder, bal-
loons, and rings that float and then explode. He was rethinking the pow-
er of the atomic bomb and its negative potential. I thought that he could
do a project in that direction because Los Alamos is so near, but when he
felt this place he preferred to work on the spirituality of the landscape.

Santa Fe abounds with spiritual and animistic influences.

I have presented the artists with the possibility of confronting this. Now

it's their turn; they will react and give their interpretations of this spiri-
tual balance or lack. Carl Michael von Hausswolff, for example, is
preparing a project called *Operation of Spirit Communication (New
Mexico Basic Minimalism Scene)*. In my conceptual framework I talk
about our anxiety about space, how we live, where we live, our bodies
and how we take care of them, how we dress and protect our identity
with fashion, etc. I'm also interested in relational aesthetics, projects
that ask for the participation of the spectator, and I hope some of the
artists will go this route.

Speed and technology diminish our space on a psychic level. To
include the spectator in a work also brings one back into oneself as a
frame of reference.

Interaction is important. Cai Guo Qiang did a project of this type in
Istanbul.[3] He wanted to connect East and West, and as we did not have
a big budget, he did it through a very delicate performance. He threw
stones from both shores of the Bosporus, the European and the Asian,
and he filmed that action. Then he installed two TV monitors in the left
and right axes of one of our most beautiful venues, the Hagia Eireni
Church. Each monitor showed his action on one side of the Bosporus
and the stones crossed virtually from one monitor to the other, symbol-
ically connecting East and West. He then invited the visitors to construct
paper planes, to write a desire on them, and make them fly in the axis of
the church connecting the entrance with the apse—representing the
human and the divine. At the end of the show in the middle of the church
there was a big, beautiful, white mountain with all the planes and all the
desires of the visitors.

This participation, encompassing the viewer, is like an intervention that
changes the equation of the activity, of object and subject, and expands
the field of vision in unexpected ways.

Yes, the autonomy of the art work is put into question. When the spec-
tators interpret the work they create it in another way. We no longer think
in mirror aesthetics, with only two sides: active artist/passive spectator.
Now the visions are prismatic. When I speak about prismatic views I do
not mean only visual perspectives; I mean emotional, ethnic, symbolic,
and others.

Many people come to live in Santa Fe to retreat from the problems of
cities and global politics. It has become a Mecca for the rich from New
York and Los Angeles.

Yes, it's an existential focus; we look for a place to hide ourselves, or to

Shirin Neshat, *Rapture*, 1999, video still.
Photo: Herb Lotz.

develop ourselves in relation to others. People who go to Santa Fe go to find this landscape, this peace. The conceptual background that I propose to the artists is an instrument of reflection on all this.

The exposure to diverse ideas from all over can imply that *mainstreamism* will result. Instead, the separate and unique triumph. In New York there once was a melting-pot mentality; now the struggle is against this leveling effect. People want to maintain their difference.

Absolutely. This is what happens with globalization. It's bringing back the extreme defense of ethnicity, of identity, so there's this struggle: globalization against identity and vice versa. I think those are two sides of the same coin. And they establish a dialectic that has not been solved.

What is the male/female ratio of artists at Santa Fe?

There will be a balanced number of women and men.

Do you see a global feminist art emerging?

Not really. I see that there are more and more women producing art who are significant in the visible arena. Their contributions are expanding the field and the visions about the meaning of art, but I do not think they are acting with the militant radicalism of the 60s and 70s. They are very conscious about their problems, but they are not schematic and rigid; they are more fluid and wiser in a way due to the work that others did before. Miwa Yanagi is a Japanese photographer whose work is futuristic and melancholic at the same time. Her works are not feminist in the traditional sense; they present women as those who open the elevator doors in large commercial stores. Those kind, silent, beautiful, and submissive women are, for me, a critique of the passive role of women. In her videos, Mariko Mori fantasizes of being a goddess.

This sounds like a menacing, retro-futuristic role for a female cyborg.

Yet Mori's work is more appealing as a meaningful spiritual negotiation.

Many women are trying to escape from the weight of patriarchal history,

Miwa Yanagi, *Eternal City 1*, 1998, billboard, 12 x 24 feet. Courtesy SITE Santa Fe International Biennial.

imagining for themselves a world without the gravity of History. Others,
like Shirin Neshat, an artist from Iran, deconstruct the arena of the patri-
archal model in Islam, where women are obliged to wear a veil in public
spaces. From Portugal, Helena Almeida, who is 64 years old, develops a
personal world in her photographs. She uses the house and its furniture
to explore how women are tied to domestic space. Monica Bonvicini,
from Italy, analyzes gender issues and the sexual politics of space. She
also criticizes with pain how we metaphorically carry the house on our
shoulders and how difficult it is to escape the domestic prison. In one of
her works, *Destroy She Said* [1998], she took excerpts from films (direct-
ed by the big macho directors of the 50s and the 60s) where there is
always a certain moment where sad, tired, or abandoned women lean
against a wall, to gain support—as if they never could stand by them-
selves. Her piece for Santa Fe will be a book on the macho world of con-
struction workers. She has been collecting answers to a very ironic and
ideological questionnaire in various cities and she will present the
results. Ghada Amer, from Egypt, analyzes the sexual connotations of
abstract painting and in Santa Fe she will create a "Love Park," trying to
reflect and reinvent affective relations and the meaning of love in our
lives. Charlene Teters is an extraordinary woman, a Native American
artist. She is analyzing how Indians are represented in the mass media,
in Disney's portrayal of Pocahontas, for example, and how that repre-
sentation mystifies and confronts the Native American reality.
Monica Bonvicini's work references Gordon Matta-Clark's famous acts
of architectural rupture. Hers is a portrayal of violence done not only to
the white cube, but also to the domestic environment. Perhaps this is
interchangeable.

At the Istanbul Biennial, the decision to exhibit more women than men
was an effort to balance the patriarchal tradition we all live under, which
is particularly strong in Islamic cultures. Women are renovating the dis-
course of contemporary art and the critique of culture—to highlight this
was a significant gesture. I think women artists of the 90s are more flu-
id than before, finding their way like weavers, adapting to the obstacles
and circumventing them, not destroying them. They are trying to con-
struct together with the male.
Many heterosexual men have taken a certain role in the art world that,
among other things, celebrates adolescent machismo: Jason Rhoades,
Paul McCarthy, John Bock, and Jonathan Meese, for example.

Yes, I believe this is a backlash. They are saying to all women, "You have

already achieved what you wanted. You are equal now. You are free. But still look how powerful and nice we are." But in fact men are terrified that women will steal their power, so they reclaim male power. I hesitate to use these words, but it is kind of a new fascism, a macho fascism. When men feel that their masculinity is in question, they feel a need to affirm it more and more. The fetish of the phallus is still there, the idea of creation as ejaculation—puff!, like with Pollock. It is a very male form of affirmation. I think some people become very aggressive when you say that you are even a little bit feminist, because they think you are going to bomb the established order.

There is no such thing as being a little bit feminist.

Maybe I should say a soft feminist. Women are more and more conscious of the unbalanced interchange that patriarchal society offers them. "Give me your sex, take care of my children, clean my house, and I will give you some money, security, and protection, but you have to obey and be good to me. And if you want to work, do it, but don't forget your other duties." When we say, "I see things in a different way," the violence might start. But we should say to men, "Don't worry, we still like you. We would only like to invent other models of affective relations and we want a better distribution of the domestic obligations and of the power relationships. We're not going to cut your throat."

It's not the throat that they are concerned about.

Yes, of course. I think that women's art is starting to be part of the river of art, whose present course is not militant.

Do you feel any discrimination as a female curator?

We should ask the Guerrilla Girls to count how many women are in the best curatorial posts. Catherine David was the first one in 50 years to direct *documenta*. I do not remember any women directing the Venice Biennale. Most of us are in peripheral situations, and I know that I have to work harder than my male colleagues. I am a member of an association of curators called VOTI. This association has been accused of being a male club, even if a lot of women are members. But this is because boys are still more visible; we are more silent, more discrete. We are still looking for our own language, but we are still obliged to use the language of the Father.

What about the other fight, the one we women have with our mothers and the mother in ourselves?

Yes, that's another issue. We also have to fight the possessive and vampiric power of mothers and our own desire to embrace everything. We have

to control hysteria, which for me is just a protest of the body against the lack of power, the lack of voice. As for the lack of phallus (not the lack of penis), I laugh every time I think of our supposed "envy of the penis." We have to start to be aware that Freud is not the only truth and that psychoanalysis is a very macho thing. In the Jungian sense, everyone has a masculine and feminine part, and we must integrate them. At the same time, we are obliged to deconstruct all the laws given to us by the fathers. So there is a lot of work to do, but we shouldn't be afraid of anything!

1. *Cream: Contemporary Art in Culture* (London: Phaidon, 1998). **2.** Rosa Martínez organized the 3rd SITE Santa Fe Biennial (New Mexico, 1999). **3.** Cai Guo Qiang, *The Other Shore*, 1997.

hans-ulrich obrist
02/2000

In a 1971 essay entitled "The Dilemmas of the Curator," Edward Fry list-
ed what he saw as the three roles that define the curator's position: first,
as "the caretaker of the secular relics of a nation's cultural heritage"; sec-
ond, as "the assembler," through acquisition, "of an otherwise non-exis-
tent cultural heritage"; and third, as "ideologue."[1] As a contemporary cura-
tor, do you see your role as the un-doer of this traditional description?

> I think Fry's definition is partially obsolete, partially valid. The museum
> has a storage function, for which the curator is caretaker. What is clear
> is that amidst all the changes within the museum, the collection of the
> museum remains its backbone. Artists, especially in the last decade, have
> made clear that art works have to be taken care of, but this is only one
> aspect of a greater complexity. So rather than an *un-doer*, I am a nego-
> tiator of new forms of curating; a catalyst, someone who builds pedes-
> trian bridges from the art to many different audiences. There is now an
> oscillation between museum and non-museum spaces, a back-and-forth
> movement through which to negotiate new exhibition positions.

But this is not a 60s "guerrilla" action, one that placed exhibitions out-
side of the museum or even made these quarters un-enterable. What is
the contemporary impetus?

> It is a less antagonistic situation, but there's a similar approach to the
> audience. There has often been a demagogical relationship between
> museums and the public. I have never believed that there is such a thing
> as audience in this abstract sense. Encounters are more to the point. Yes,
> exhibitions can create very unexpected encounters.

Can you give me some examples?

> Two examples are the museum projects of Rem Koolhaas: both his unre-
> alized ZKM[2] project in Karlsruhe and the more recently unrealized one at
> MoMA in New York. The key issue here is the complex reality of bringing
> together the mass experience and the laboratory, which encourages
> slowness and focus. In both our libraries and museums, we organize the
> co-existence of almost all urban noises and experiences. In his most
> recent museum projects, Koolhaas tries to create a kind of topology of
> museums. And there are other types, as well.

Many artists have had a desire to show in different spaces outside the
museum context, to bridge the gulf between art and life.

> Alighiero e Boetti is a pioneer of the idea of the exhibition as a network,
> and he anticipated the artist's practice as both a global and a local one. He
> exhibited on an airliner, with the assistance of the Museum in Progress
> [Vienna], and he worked with art that was sent through the mail, as an

exchange with different communities. But mostly he propelled me to
think about artists' unrealized projects. These are the most interesting.
They could not happen within the often narrow parameters of exhibition
conventions. This brings us back to the importance of listening to the
infinite conversations with artists and architects and other practitioners
whose unrealized projects can be a good point of departure.

Were you trained as a curator?

No, I studied economics and social science. But before I entered the uni-
versity I was reading about art. I knew then that I wanted to be involved
in the organizational aspects of it. I was interested in social conditions,
and in how they played out in different economic models. I went to many
lectures of Ota Sik, who was the designated economic minister in Prague
in 1968. After Prague he taught in Switzerland and worked on a third way
to describe a space between communism and capitalism.

So, intellectually, you emerge from the socio-political arena.

At the time I somehow intuited that I wanted to be located only in the art
context. Since I was a teenager I have had dialogues with artists and a
desire, or a necessity, to find ways to work with artists, realizing proj-
ects that could not be realized in the prevailing modes. You could say
that these dialogues were my main study out of the university. Boetti
was one of my teachers in this sense, and he encouraged me to avoid
any kinds of routines. But my main reference is Alexander Dorner's book,
The Way Beyond "Art",[3] published in the 1940s in the United States. He
defined the museum as a laboratory of permanent transformation with
its borders between object and process. Dorner ran the Hannover
Museum in the first two decades of the twentieth century and later emi-
grated to the US to escape the Nazis. He worked with Lissitzky on the
Abstract Cabinet[4] and was in a close dialogue with artists at the time
regarding the nature of museums. He also influenced the Bauhaus as
well as the laboratory years at the Museum of Modern Art.[5] As a curator,
I am more interested in these years than what came later. The idea of the
laboratory museum resists fixed ideas to become a place of contribu-
tion and participation, a power station with a fluid identity pioneering
new ideas within the locus of the institution. Keeping things fluid means
museums and artists are in close dialogue. Also, great collections
emerge from pioneering situations: by collecting an artist early, and not
waiting until things are clearer.

While the museum remains a locus of activity, there has been a tenden-
cy to move outside its walls or to use it in ways for which it wasn't

designed. Changing the conceptual structure is something you have actively sought to do in your work. For instance, your exhibition, *do it*, uses uncommon curatorial strategies within normal venues. Another example is *Cities on the Move*, co-curated with Hou Hanru. Each deals with itinerant exhibitions, ones that change with their locations.

In the beginning of the 90s, when I organized my first exhibitions—my *Kitchen* show; a show of Richter in the Nietzsche house in Sils Maria, Switzerland; a Boltanski show in a monastery; the Boetti show on an airplane—there was a moment when artists were longing for such laboratory situations, not only within museums but outside of them. It's not that these things were invented in the 90s. They took place in the 60s, but they were forgotten. In the beginning of the 90s there was a desire on the artists' part to show their work differently, and now this has become a more frequent occurrence. An exhibition can take place in an elevator, a hotel, anywhere; it is the rule of the game, no longer a shift.

In the 70s there were often problems with artists working outside of conventional arenas. At Hunter College, CUNY, it was not unusual for Robert Morris to ask his graduate students to perform actions in public spaces; because of the unconventional context, many were halted as they were considered disruptive. Was this a unique misunderstanding of the moment, or has the public now been educated to expect creative acts in unusual situations?

Well, recently, curator Okwui Enwezor invited artist Liisa Roberts to do a project with ArtPace.[6] She did a work in the elevators of an office building. Due to the work, 3,000 office workers were evacuated because of fears of a bomb attack. Roberts' almost inaudible sound piece triggered this crisis state. It's not just the museum—an inside or an outside—it is also about the different ideas of museums. It is less a question of finding different spaces now than a question of the temporal aspect of exhibitions.

Left: *Cities on the Move*, installation view,
Kiasma, Helsinki. Courtesy Hou Hanru.

Right: Tomoko Takahashi, *Office Work*, 1999,
installation view, *Laboratorium*
exhibition, Antwerp. Photo: Thorsten
Arendt/artdoc.

Steve McQueen, *With Soane, Echo, System II*,
1999, installation view, Sir John Soane
Museum, London. Photo: Emily Barney.

The visionary British architect Cedric Price speaks about the fourth
dimension: height, breadth, length, and time. Time is the key because
of the whole nature, not just the presentation of materials and ideas, but
the actual consumption of ideas and images as they exist in time.

Tell me about your newest exhibition at the Sir John Soane Museum
in London.

Sir John Soane was an architect who died in 1848. The space was once
his family home and studio, then later it became a museum for his ency-
clopedic collections. Beyond housing the collections, Soane also creat-
ed a dense network of relations between objects and the conditions of
light. The title of the show here, *Retrace Your Steps: Remember
Tomorrow*, evolved from an ongoing dialogue. In this case, it was with
the artist Cerith Wyn Evans. Our meetings in the museum became a reg-
ular activity, almost an obsession, and after a while the idea of an imag-
inary exhibition began to take hold.

Why does this museum interest you?

The space consists of a narrow private house that is a multi-layered
place. Soane was a mannerist architect whose design and ideas have
attracted many artists and architects. We've reached a moment where
many museums are built to follow the reasoned ideology of the white
cube, or as a symbol, like the Guggenheim in Bilbao. Yet these two pos-
sibilities are surrounded by many other possibilities, which are worth
being considered as well.

The Soane Museum gives the visitor no directions, no labels; it
doesn't tell you where to go. One navigates alone to find a path. In the
entrance there is only a text by Soane. The space is inspiring in that as a
house, it is a breach in the threshold between art and life. Upon enter-
ing people sign Soane's guest book, so you could say that 150 years after
his death, they are still his guests. Not only does it provide a different
viewing experience, but the artists do different work there than in the
traditional white cube.

How did the artists veer from their typical work?

Many of the works were on the threshold of the visible/invisible bound-
ary. Richard Hamilton, for example, installed his work in a shrine space
where different layers of images hide behind each other. Behind a
Hogarth you see the Hamilton. Most of the artists experimented with
new works that addressed this museum's specific experience. Unusual
issues concerning the Soane Museum make it important for a visit. There
is a special museum typology, like the Guggenheim or the Whitney. At

this moment when things are bigger and bigger, like the Millennium
Dome and the new Tate,[7] I thought it important to have a small exhibition
in a distinguished but tiny house; to say that it's not through scale that art
or buildings are made important.

You suggest that there are a number of different categories or layers one
must consider in organizing exhibitions. Could you clarify?

On the one hand, there are contexts where contemporary shows always
take place, such as in museums for contemporary art. *Migrateurs*, a
series of exhibitions that I curated for the Musee d'Art Moderne de la
Ville de Paris, tried to shift the rule of an institution that has a continu-
ing history of showing contemporary art. Another possibility is to show
at a museum where contemporary art exhibitions do not take place, like
the Monastery Museum or the Soane Museum, where you might create
an audience which has this unexpected encounter with contemporary
art. For instance, consider the contemporary art audience that comes to
see Steve McQueen's work and discovers, through the back door, a 19th-
century museum.[8] People follow their habits. I'm interested in ruptur-
ing indifference. Then there's a third level of exhibition which does not
occur in a museum, like the show I organized in my kitchen, or the one
with Boetti on the airliner. However, Boetti occupies both the third and
fourth levels because it's neither a museum nor a single location. It is
mobile: You don't come to the show, the show comes to you. Thus the
fourth category is the mobile exhibition, one that can be carried. The
Nano Museum, for instance, is a portable museum, a small frame that I
founded with the German artist Hans Peter Feldmann. It's a museum
that we carried all over the world to show to friends and strangers on
the street. Another category is an exhibition where the visitor doesn't
have to come to a place to see it; the museum is both actual and virtual.
This would lead us to the Viennese Museum in Progress, which organ-
izes exhibitions in the newspapers or produces Boetti's puzzles, which
are distributed on the airlines. There is actually a sixth category, which
is where the exhibition *do it* comes in. There, recipes or instructions are
faxed or sent or just provided in a booklet.

How did you choose the artists for this exhibition?

do it started with a dialogue with French artists Christian Boltanski and
Bertrand Lavier. I was interested in artists working with installation. It's
no longer just objects being exhibited, but complex installations which, if
reconstituted in the future, are altered and can be realized not only by the
artist or an assistant, but by anyone. Just as Alison Knowles' early work

wasn't about following exactly what an artist says, but about possible mis-
understandings as part of a cultural translation.[9] This could describe cer-
tain artists in the 60s and 70s who were interested in open compositions.
Yes, all of this emanates from Duchamp's work, such as his "unhappy"
ready-mades for which he sent instructions from Argentina for his sister
to realize. He also had a definitive text, a "pick-up dictionary," where the
viewer could cross out words, or his "museum in a suitcase."

This can still be done today. I am interested in the exhibition that can or
cannot be realized, occurring in contexts that can't afford the costs of a
conventional exhibition. So, if there is a desire in a community, they can
just do it. This is the minimum rule.

So the artist is not needed to perform these works. They're translated
by the museum director or curator. How many different museums are
we talking about?

About forty in all. Twenty in America organized by the ICI,[10] and twenty
in Europe and Asia that were self-organized. These are just the ones we
know of.

Cultural institutions have translated this concept in a variety of unique
ways because of their architecture, their language, or other variables
that you can probably describe.

Another aspect of how this is interpreted is through the input of various
directors or curatorial staff, while others, like in Glasgow or Bangkok,
worked in collaboration with local artists. I'm interested in shows with-
out a beginning or end, ones that rupture the homogenization of the
museum and the exhibition. It is about mutations; as Rirkrit Tiravanija
pointed out, recipes mutate over time.

This leads us to *Cities on the Move*, which I co-curated with Hou
Hanru. *Cities on the Move* involved close participation with the practi-
tioners. It started out like a non-a-priori situation; like the city, it is cre-
ated out of happenstance. We didn't plan to do a semantic, illustrative
exhibition about the city. We just wanted to do a show about the artists
and architects in Asia, and to exhibit them in Europe.

What is the origin of your collaboration with Hou Hanru?

It is a long story. In 1990, I had a grant from the Cartier Foundation to
spend three months in Jouy-en-Josas, near Paris, where I met the
Chinese artist, Huang Yong Ping; some weeks later in Paris I met the cura-
tor Hou Hanru. Hou Hanru was traveling back and forth to China. Then I
myself traveled to Japan, Korea, and Bangkok to teach and curate exhi-
bitions. At a certain moment we decided to pool our research to create

NO SMOKING

To each WHITE thing &

To each YELLOW Thing

To each BLACK thing &

To each

BREAD FRUIT
\'bred-,fru:t\ n (1692)
: a round usu. seedless fruit
that resembles
bread in color
and texture
when baked;
also: a tall

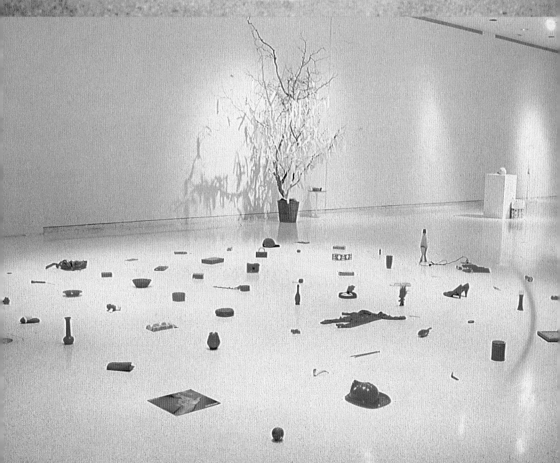

a larger project while the Secession agreed to provide modest funding.
We had to improvise a lot but this is how *Cities on the Move* evolved.
The exhibition business needs modesty!
But *Cities on the Move* is a huge exhibition.

Yes, it grew, but in the beginning it was not this huge statement. We had
a desire to show work from Asia and came to realize that artists and film-
makers are obsessed with cities, mainly because the cities in Asia of the
90s have become incredible urban laboratories. We thought this was an
interesting topic, and this exhibition as a performative space was creat-
ed through happenstance.

Cities on the Move is about the chaos in all cities as we move into the
21st century, but especially in the Asian cities where the economies of
the 20th century have undergone radical change.

It's interesting, the idea of the Asian city as chaotic, because it is really a
different kind of order. Only from our perspective is it chaos. Shigeru
Ban, the Japanese architect, pointed out to me that the Western concept
of Asian cities as chaotic is a cliché.

The time one has to organize an exhibition is shrinking. As curator you
have only six or eight months to organize a show. So, often it is superfi-
cial research. Can you explain how you get past this?

Yes. It would be nice to have two or three years to prepare an exhibition,
but hardly any museum gives you that. So we decided to use the tour as
an unraveling device; to make possible a longer research period by in-
cluding the next venue as part of the complex learning system. It wasn't
an elaborate exhibition in the beginning, but it became a "traveling lab-
oratory on the city," a learning system that goes beyond the framework.
It's the opposite of most traveling shows because it's an evolving exhi-
bition. It doesn't start from a spectacular statement that "this is the art of
Asia" or "these are the ten artists." Instead, it starts with a doubt, a ques-
tion. It doesn't know where it's going, but it listens. I don't believe in the
authoritative curator who says, "This is it, this is where it goes and now
we send it out in the world."

Give me some examples of artists and architects who are working with
this show.

At every venue an artist worked in close dialogue with an architect. The
material was revisited and, through new dialogue, each city developed
a completely different show. For Vienna, it was the Chinese architect
Yung Ho Chang. For London, Rem Koolhaas and Ola Scheren, and for
Helsinki it was Shigeru Ban.

Previous two pages: Alison Knowles,
Homage to Each Red Thing, 1997, 3 installation
views from *do it* exhibitions at Dunlop Art
Gallery, Regina, Saskatchewan, Canada;
Institute of Contemporary Art, Maine College
of Art, Portland, Maine; Museum of Art,
Fort Lauderdale, Florida.

Instructions: Divide the exhibition
space floor into squares of any size.
Put one red thing into each square. For
example: a piece of fruit; a doll with a
red hat; a shoe. Completely cover the
floor in this way. Courtesy Independent
Curators International.

I saw the show at P.S.1 in New York but did not get a sense of its organic methodology.

At P.S.1 there wasn't the full hardware of the show, as it was a smaller version. We treated it instead like a work in progress where artists submitted many videos and slides, once again joining the serpent's tail.

Where is the show now?

It stopped in Helsinki. It is resting. We are thinking about a new version and a book.

Having gone through this long process of working with different institutions and architects on one show, has your perception of the curator's role changed?

The curator is the catalyst of relations and situations. For instance, many things were triggered by *Cities on the Move*. Artists and architects worked together and interdisciplinary dialogues were inspired. If there is a "big project" in my work it's to create unexpected collaborations that go beyond boundaries of discipline and geography and age, transmitting knowledge generationally. I'm uncomfortable with today's tendency to define the "young-artist group show." It's a bit of a cliché, like an Olympics in sports. It's a more enriching experience to have a 20-year-old artist with a 70-year-old artist. Exhibitions have to go past geographical and cultural boundaries; they must be transgenerational and interdisciplinary.

1. Edward Fry, "The Dilemmas of the Curator," in Brian O'Doherty, ed., *Museums in Crisis* (New York: George Braziller, 1972), 110. **2.** Zentrum für Kunst und Medientechnologie, Karlsruhe, Germany. **3.** Alexander Dorner, *The Way Beyond "Art": The Work of Herbert Bayer* (New York: Wittenborn, Schultz, Inc., 1947). **4.** El Lissitzky's *Abstract Cabinet* was shown at the Landesmuseum in Hannover in 1927 and 1928. **5.** For a history of the laboratory years (1930s to 1950s) at MoMA under the directorship of Alfred Barr, see Mary Anne Staniszewski, *The Power of Display: A History of Exhibition Installations at the Museum of Modern Art* (Cambridge, Mass. and London, England: The MIT Press, 1998). **6.** ArtPace is a foundation for contemporary art in San Antonio, Texas. **7.** Both located in London, the Millennium Dome was erected to celebrate the year 2000 and was dismantled in 2001, and the new Tate Modern opened in 2000. **8.** Steve McQueen is a London-based artist who works primarily with film and video. **9.** Born in 1933, the American artist Alison Knowles began her career in the early 1960s as a member of the loosely unified Fluxus group. **10.** Independent Curators International was founded in New York in 1975.

dan cameron
11/2000

As a senior curator at the New Museum you're charged with mounting provocative, innovative, and experimental exhibitions that encourage debate and discussion about culture and, among other things, concepts of persona as represented in contemporary art. The Oxford English Dictionary refers to the Latin root of "curator" as one way of defining the word: overseer, agent, or guardian for persons legally unfit to conduct themselves, like minors or lunatics in the Romantic tradition. How much weight do you think a contemporary curator should give to the artist's mythic construction in relation to culture?

A certain amount of our work is championing the vital practice of the artist within society, but regarding persona, I worry that the discussion of art moves into that area too quickly. I don't think it is the artist's persona or the subject's persona, or your persona or mine, that is at issue. The terrain involves cultural priorities and hierarchies, and how art fights for its visibility and effectiveness in society today. The stakes are very high.

The New Museum has been doing provocative one-person exhibitions of artists like Martha Rosler, Pierre et Gilles, Carolee Schneemann, David Wojnarowicz, and Adrian Piper, all of whom use their own persona as subject matter.

Absolutely, and I don't consider that exceptional; we're simply doing what we are supposed to do. If you're dealing with contemporary art as your primary focus in a museum, it's already an intellectually stimulating, embracing kind of experience that involves the senses and the mind. Yes, our exhibitions are provocative, but they're intended to be about what art is addressing today. I think our society is invested in distracting us from the culturally and personally transforming experience that an ongoing engagement with art can bring.

For the artist? The curator, the viewer, the patron? It's for everyone; art is a way of understanding reality. We know that an exhibition is not the world, but it addresses what the world is about. We take from that and it gives us ways to cope with reality, whether it's on an interpersonal level, an interior spiritual or psychic level in social relationships, or in political relationships. The current Martha Rosler show takes that understanding to an extreme and talks about the role of the citizen in

contemporary society, and also significant issues of our time such as abuses of government and how power is exercised in public situations.[1]

> The critics in the 70s did not consider Martha Rosler a remarkable artist, but now she has gained recognition.

I feel there's an intellectual decadence that's taking hold in the most influential cultural institution of our time, the art museum, which clouds the understanding of the recent past. One of my hypotheses for this state of affairs is that most of these museums had acquisition and exhibition policies that determined their commitment to certain movements, and they cannot change course. Artists like Schneemann or Rosler could have been accepted only if they conformed to the art world's idea of what was marketable or historically sanctioned. They had other values, and were punished for acting on them. The harshest punishment the art world gives out is to ignore someone and hope they'll disappear. It takes a generation for younger artists—who are by nature very inquisitive and skeptical about what they're told—to discover these marginalized artists as more legitimate predecessors to what they're trying to do.

> Young people and older people with hindsight are unthreatened by ideas that were once considered unacceptable.

It's clear that a Whitney, Guggenheim, or MoMA simply cannot embrace fresh thinking about recent history because to do so would call into question the value of some of the art movements and artists that they put so much institutional weight behind twenty-five or thirty years ago. There's no going back for them. Yes, they might buy something from the 60s that escaped their attention, usually by a female, African-American, Hispanic, or Asian artist. "Oops, we forgot Nam June Paik! Let's get him into the canon!" The New Museum's mission is very clear. You don't just take the art of the moment and blow it up, make a production number out of it; you set up situations which ask the viewer to think about recent history in a different way. What if the 60s and 70s really looked like this, and not like what we've had crammed down our throats all these years?

> That was a problem with *documenta X*. While the art of the 60s and 70s was exhibited as the forefather of newer conceptual works, it was too far removed from the cultural context that had inspired it.

I didn't think it was successful at all, and yes, it was frustrating. The curator,

Catherine David, simply took certain historical artists and moved them
to the center rather than questioning the apparatus, which had overestimated some artists and left others undervalued. It seemed she was setting up a new hierarchy, partly based on what was accepted before and partly on new information. Why we had Michelangelo Pistoletto and Richard Hamilton along with Öyvind Fahlström and Hélio Oiticica and Marcel Broodthaers... some of it was exciting and new, and some we've seen for the past ten or fifteen years. So any groundwork for a new aesthetic philosophy became muddy.

When I started at the New Museum five years ago we tried to develop shows with an interlinking focus. We have set up a sustained investigation into museum practice and how it reflects certain historical viewpoints. Showing individual artists' works has been the primary focus of the program for the past four years. Showing Martha Rosler's practice and ideas in depth, for example, immerses people in them, so that they look at the world and make transformations in their own relationship to culture in a way that showing a couple of pieces in a group show would not influence them to do.

So the New Museum's mission is to show artists who were not in line with the prevailing formal concerns. Many had not had museum shows.

It's scary to think about how powerful a grip formalism still has on our thinking and institutional practice. I'm talking about the legacy of Clement Greenberg; not his ideas themselves, but the way they were wielded in the art world.

Yes, and Minimalism was also a tyranny.

In the past ten years the world has opened up; our relationship to our past, to politics, and to the global reality is different, transformed, and has now become the new model.

But the artists of today who are working in new media aren't intimidated by Greenbergian autocracy.

Curiously enough, many of the people who might come to the New Museum and support the Martha Rosler exhibition would find the Pierre et Gilles show, going on simultaneously, a travesty.

Why?

A certain part of the art community supports Martha Rosler's work because it is critical of society and politics, and they believe it is the only appropriate role for art today. We feel the effects of this dogmatic

approach in that they dominate the art.

Some art is jarring in terms of contemporary politics, and many people don't want to deal with this confrontation. The 60s and 70s were bloody times in our culture. In the aftermath there was a return to a glorified materialism. This was, among other things, a backlash against social revolutions—the dirty stuff of the 70s.

Pierre et Gilles' practice as artists was—and is—very provocative in many ways, and the experience of being "overlooked" is something I respond to. They're doing what innumerable artists have done historically, which is to create a visual world that they themselves would like to live in. They build sets, and use all the details of make-up, lighting, and costume in their photographs to participate in the world of mass culture—of music, magazines, and lifestyle. However, the art world is still conflicted about its relationship to mass culture and there is that prejudice to overcome.

There has been an ongoing relationship between mass culture and high art for over half a century—well before Pop art. Today there are innumerable artist/photographers who work in this slot. It isn't a question.

Most people understand the relationship between art and mass culture as artists raiding the world of info-tainment, and producing art work from their take on the larger culture. Pierre et Gilles do the opposite: They

Left: Pierre et Gilles, *Meduse-zuleika*, 1990.
Courtesy New Museum of Contemporary Art.

Right: David Wojnarowicz, Untitled, 1993.
Courtesy New Museum of Contemporary Art.

don't really care very much about the art world—they're convinced that
what they're doing is art. There's an enormous argument about the
show.[2] Many of my colleagues are embarrassed. They feel that after all
the New Museum's venerated history of consciousness-raising and polit-
ical correctness, showing Paris pretty boys is a travesty. It astounds me.

And how do the trustees respond?

The New Museum has a uniquely supportive board, which is at home with
our mission and the ways it has developed over time. They love the fact
that people are responding to the pleasure principle in Pierre et Gilles'
work, and they also loved the Rosler show. Being a board member of a
successful institution is attractive as social status, yet we don't want a
board that believes the institution could be undermined through too much
experimentation or radical positioning. The New Museum was founded by
a curator (a rare thing among museums) on the premise of curatorial
entrepreneurship, which should continuously redefine itself. That's the
philosophy of this museum and it's why we don't have a big collection.

How do you deal with outside funding in terms of
accommodating an external agenda that may be
contrary to the Museum's curatorial philosophy?

Lisa Phillips[3] has been instrumental in making sure that the fiscal health
of the museum is such that when we do a show we're fully invested in its
content, and that if we can't get funding from corporations or founda-
tions, we won't have to cancel that exhibition. We make sure we're rais-
ing enough money for the museum as a whole, so these gaps can be tak-
en care of without falling into a deficit. This is radical; once we decide
what we'll do, there's no backing down.

I want to discuss other recent exhibitions at the
New Museum. *Picturing the Modern Amazon*
presented women exhibiting their own bodies
as objects of art.[4] It dealt with the liberation of
the image of the female bodybuilder, the body
as an art object, continuing the dialogue about
the freedom with which women perceive them-
selves, as opposed to culturally imposed expec-
tations. How do you see this entering the larger
dialogue?

There was an ambiguity about who the artists were: Were they the people
making the drawings and photos of the women, or were the women them-
selves functioning as artists? That was part of the curatorial premise. It

enters public discourse through the issues of the body and gender par-
ity, with men no longer the exclusive occupants of this domain. The work
is about contemporary concepts of beauty. Unlike in earlier generations,
a growing number of people are now consumed with perfecting their
image of the body. Bodies are not "natural" anymore, but are something
we create for ourselves.

The exhibition by David Wojnarowicz is a per-
sonal narrative about AIDS.[5] Memoirs and nar-
ratives of repressed histories are productive
strategies in global culture.

Wojnarowicz was born in 1954 and had a very violent upbringing. His
father actually killed himself with a shotgun, and his mother ran away
when he was very young. He had an early introduction to sex and for a
while survived as a hustler in New York, though his dream was to be a
poet. He came under the tutelage of Peter Hujar, who taught him to be the
artist he wanted to be. He had a really radical political relationship to
society at large and the institutional homophobia that allowed AIDS to
become epidemic. He was a Renaissance man, not only doing paintings
or sculptures, but also amazing videos, a brilliant level of writing, and
music. He was popular briefly in the mid-80s, and was in the 1985
Whitney Biennial, but it didn't last. At the time of his death in 1992 many
people had written him off as an extremist kook. It wasn't until later that
he began to be appreciated as one of the major artistic figures of his time.
The extreme nature of his vision prevented him from reaching the larg-
er public that he deserved. The show was an effort to introduce him to a
generation of artists who hadn't seen his work. It was a great project in
terms of the public response—very moving and powerful.

Do you see the New Museum as the social histo-
rian of art museums?

It's actually a revisionist institution. In the next few years we will have
given about twenty of these artists one-person shows, then we will
return to group exhibitions.

The New Museum has also been in the forefront of
bringing Latin and South American art to this city.
In 1999, you gave the pioneering Brazilian artist
Cildo Meireles, born in 1948, his first comprehen-
sive show in the US. The works of Meireles and
another South American artist the New Museum
has recently shown, Doris Salcedo, reference the

political and sensual aspects of Conceptualism and Minimalism that distinguish South and Latin American art in the 60s and 70s from those movements in the United States.

A journalist in Rio de Janeiro recently asked me if Americans still exoticize Brazilian art as a curiosity. I think it's just the opposite: Americans have a strong tendency to treat Latin America as a lesser extension of ourselves, and still to see Europe as the ultimate cultural arbiter. We look to Europe for approval, while looking at South America as our little brothers; it's a colonialist attitude. We don't take these cultures seriously as producers of fine art. Artists like Meireles come out of a clearly defined historical tradition that is absolutely distinct from American aesthetics. To understand him, you have to understand Lygia Clark or Hélio Oiticica, the older Latin American artists of mid-century who influenced him. Their transformation of geometry into a socially/critically-based art form after the European-derived Neo-Constructivist tradition is unprecedented. In the States we think of political art in especially intellectualized ways—as appealing to the mind. These artists believed they could create a better society by appealing to the senses as well as to the intellect.

How do you wish to be perceived in terms of the globalist picture?

Well, I'm worried that there's a tendency to confuse the curator with the institution's identity. I consider myself a curator first and foremost, and just as I did as an independent curator, I work to bring things together. My first major exhibition in 1986, *Art and its Double*,[6] is seen as a landmark show of the 80s; it introduced certain tendencies in American art to Europe.

Who was in the show?

Cindy Sherman, Barbara Kruger, Sherry Levine, Sarah Charlesworth, Matt Mullican, Peter Halley, Jeff Koons, Robert Gober, and younger artists never seen in Europe before: Haim Steinbach, for example, and Ashley Bickerton. I found myself an American curator working in Europe on what I saw happening in the United States—without an American audience to present it to. Most of my projects at that time were in Spain, but I also did international shows. I was a co-organizer of *Aperto* in 1988, the first year that artists from the Soviet Union and Eastern countries were included. That was also my first exposure to contemporary international art on a large scale. After that I wanted to devote my practice to global issues. I became more involved with Latin American art in response to *Magiciens de la Terre*, which was very influential at the time.

In 1994 I mounted an exhibition at the Reina Sofía in Madrid, called
Cooked and Raw, which was a play on Lévi-Strauss' work. In it I made
no distinction between artists from industrialized and developing coun-
tries, which I thought had been the fatal flaw of other global shows.
These experiences had an enormous impact on me as a curator. I've tried
to bring that to my work at the New Museum. I think New York at the
beginning of the 21st century is not unlike Paris fifty years ago. Borders
are moving and priorities are changing; there's no longer a center/periph-
ery relationship with the rest of the world. Globalism counteracts the
homogenization of art—the McDonaldization of the world—and the New
Museum provides a framework for looking at this new world.

1. *Martha Rosler: Positions in the Life World*, July 15 to October 8, 2000. **2.** *Pierre et Gilles*,
September 15, 2000, to January 7, 2001. **3.** Lisa Phillips is the Director of the New Museum.
4. *Picturing the Modern Amazon*, organized by Laurie Fierstein, Joanna Frueh, and Judith Stein,
March 30 to June 25, 2000. **5.** *Fever: The Art of David Wojnarowicz*, January 21 to June 20, 1999.
6. *Art and its Double* was shown in Barcelona and Madrid, 1986-87.

barbara london
12/2000

Generations of artists have employed new technologies as part of the
ongoing experimentation with the tools of artistic production. Andy
Warhol, who frequently used an overhead projector, claimed that he
wanted to paint like a machine. Refracting instruments, the camera
obscura/lucida, and the microscope-inspired artists of the 16th and 17th
centuries, and now images made with digitally-based pixels produced
by an electronic paint box are replacing negatives, celluloid, or tapes. As
a curator of video at MoMA, you have been involved with new media
for many years.

> Yes, I started out when video was the cutting edge. As technology
> evolved and as artists continued to work with the latest tools, I continued
> to incorporate the "new" into my curatorial purview, my thinking, and
> my practice.

Tell me first about how you became involved in media.

> Originally, when I did my graduate work at the Institute of Fine Arts of
> NYU, I studied Islamic art, interested in the trade route between China
> and the Near East. I left graduate school and went to Europe. When I
> returned, I took a job at The Museum of Modern Art in our International
> Program, which still circulates exhibitions abroad and liaisons interna-
> tionally with other museums. I assisted an important young MoMA cura-
> tor of the 70s, Jennifer Licht, who organized an up-to-the-minute exhi-
> bition with such artists as Robert Morris, Richard Serra, and Lynda
> Benglis. I assembled the videotape section of that show, which the
> Museum sent to Australia. Then Riva Castleman offered me a curatori-
> al position in the Department of Prints and Illustrated Books; at the same
> time, the NEA[1] gave the Museum a grant to buy its first video equipment.
> I picked up the "hot potato" of video and simultaneously started the
> Museum's artists'-book collection. Video and books are relatively inex-
> pensive multiples and have the potential of easily reaching interested
> audiences.

> Recently, I had a conversation with Paul Pfeiffer, who had made a
> similar switch of mediums. He studied printmaking at the San Francisco
> Art Institute. Later, when he was teaching at Parsons School of Art and
> Design, he taught himself how to work with the computer because his
> students wanted to learn.

It makes sense that these two forms of reproduction—the electronic and
the print multiple—would converge in your career.

> For the first few years, the Museum's ongoing video exhibition program
> was under the umbrella of our contemporary exhibition program,

"Projects." Back then I hung out at places like Castelli-Sonnabend Tapes and Films, the Kitchen, and the Anthology Film Archives, going to all of their video screenings, having coffee afterwards with people like Nam June Paik, Shigeko Kubota, who was Anthology's video curator, Juan Downey, and others. Eventually I migrated over to the Museum's Film Department, which became the Department of Film and Video. Contemporary art is as much about concepts as materials, and artists use whatever medium suits their ideas. In the 1970s, the sculptor Richard Serra began working with film and video, almost to get himself "out of a corner" he was in.

Let's talk about the effect of the new media on the perception and structure of time. As one of the commissioners for *Media_City Seoul 2000*, you wrote a catalogue essay on the nature of time in video and quoted Gary Hill. "Video" he said, "allowed a certain real-time play, the possibility of thinking out loud; a process immediately accessible and more parallel to thinking. Time is what is essential to video."[2]

In dealing with the durational sense of time, an artist like Bruce Nauman would work in his studio alone, and repeat dance-like movements in front of the camera for the length of the tape, which back in 1969 meant either thirty or sixty minutes. At the beginning, Nauman, Peter Campus, and other artists examined the complexities of time that resulted from the interplay between the viewer, the live camera, and pre-recorded video material. Time could be speeded up, slowed down, frozen, and otherwise mangled within a context that allowed active viewer participation. In the installation form, video extends both space and time. Film cannot do this. What you see in film has happened in the past.

The early videomaker Ed Emshwiller would talk about time as "stuff." He became frustrated as a painter, because he wanted his viewers to experience the progressive changes he had made to the surface of his canvases. He found that the only way he could do this was to make computer-based video animations. Back then it was a different ball game: Computers were analogue, large, and ultra-expensive.

In some of Gary Hill's installations, time feels tangible. In Hill's *Inasmuch as It Is Always Already Taking Place* [1990], a figure is broken apart. The actual body parts are contained as short loops on 16 TV screens installed on a shelf. The body can never be still, and neither can time. They quiver.

Yes, his work involves the body in interesting ways.

The body takes us to Joan Jonas and Lynda Benglis, who were very

important in defining that gray zone between video and performance.
They worked with their own bodies in front of a live camera, checking
their image on an adjacent monitor. In her first videotape, *Organic Honey*
[1973], Jonas worked with masks to represent various alter egos.

More recently, in her tape *Host* [1997], Kristin Lucas talks to an ATM
machine that talks back. Here the CPU of Lucas' inner being didn't do so
well with a power outage. Lucas' alter ego complains that she doesn't
feel well. There are other artists, too, like Teiji Furuhashi, who deals with
the body by projecting images with which the audience interacts.

Now, due to the speed at which information travels, one has a vertigi-
nous sense of being thrust forward and a fear of being left behind. In the
beginning, artists questioned time in relation to the body, and now, with
the digital propellant, artists reflect their anxiety connected to that speed.

It's still very early in the development of "new media"; there have not
really been major breakthroughs, which will probably come out of left
field. First there was the Gutenberg printing press. Cervantes' "novel,"
Don Quixote, appeared around 150 years after the Gutenberg Bible.
Comparing today's digital sense of time to the days of the Gutenberg
Bible and Don Quixote is poetic, but with the speed of information hav-
ing increased considerably since then, another reflex takes over. Paul
Pfeiffer's work is a beautiful example of the physical anxiety produced by
this speed. His work, *John 3:16* [2000], is both psychologically and cor-
porally related to the tools of the medium.

Yes, that work is in the collection. Paul selected close-up shots of bas-
ketballs from off-the-air footage of professional games. In the comput-
er he laboriously removed the players, keeping only the close-ups of the
basketballs, which hover in space. The five thousand images of basket-
balls, shown on a flat screen jutting out from the wall in the position of
a hoop, question the god-like quality of the sports star, the game, the
mass media, and the medium of video. The title comes from the Bible:
"For God so loved the world...."

MoMA has always had an interest in new media. Tell me about the 1968
Machine show.

The full title of the show was *The Machine as Seen at the End of the
Mechanical Age*, and it was curated by Pontus Hulten. The show began
with Leonardo's drawings for his flying machine, then segued to Pierre
Jacquet-Droz's automaton of a young writer of the 18th century, and on
to computer prints made at Bell Labs through Experiments in Art and
Technology.[3] The show concluded with Nam June Paik's video portrait

of former New York Mayor John Lindsay, appropriated from a televised
press conference. Paik presented the tape in the gallery on a jerry-rigged
tape-loop device. Videocassettes were nonexistent back then.

In 1968, Paik, the Korean-born Fluxus artist, bought one of the first Sony
Portapak video sets in New York and immediately turned the camera on
the Papal entourage. His original works were like documentaries and
coincided with McLuhan's theories, but they were purely art-oriented.

After the *Machine* show, Kynaston McShine organized *Information*, a
show that looked at cybernetics and information theories. He included a
number of videotapes by artists from Latin America.

Did "Projects" evolve out of necessity to accommodate new artistic
emergences?

Yes. The Museum launched the "Projects" contemporary exhibition
series in 1971 with Keith Sonnier's video installation. Viewers walked
into a small room with a lowered ceiling. Actually, they had to duck to
get in. Able to stand up only in the middle of this room, there they saw a
camera directed at them. After they exited and entered the adjacent
space, they saw the live projected image of viewers just standing up in
the center of the space next door.

This seems like an early "surveillance" work. What were some of the oth-
er ideas that artists worked with?

I organized another "Projects" show with Peter Campus' installation, *Aen*
[1974]. When viewers entered this installation, they found a totally dark
room. A tiny spotlight was located along the base of the far wall. When
they went to investigate what the spotlight was, their live image sud-
denly appeared flat on the wall, upside down and in a stark manner. An
unobtrusive camera captured the live image. It was like coming face-to-
face with a bad dream.

In your recent curatorial work, you seem to be most interested in the con-
cept of time. Which artist has influenced you the most in this context?

Probably Nam June Paik's *TV Buddha* [1974], which is like a koan about
time. The viewer thinks, "Is the Buddha looking at his own image on the
futuristic monitor in front of him, or is it a recorded image?" The only
way viewers can tell is by putting their hand over the camera and see-
ing that it is live. Nam June thought a lot about different issues regard-
ing time in video.

Surveillance is another interesting issue. Often used for control inside
Eastern Europe—or in Deleuze's term, "the control society"—it has
become an aesthetic device for many underground artists and presently

is used by mainstream video artists. Many of these videos are Warholian,
in that they refer to the tedium of the everyday.

In the 1970s and 1980s, artists explored surveillance. Julia Scher went to town with this idea. In *Video Time*, our survey collection show in *MoMA 2000* this year, we presented a feature-length videotape by the German artist Michael Klier. *The Giant* [1982-1983] is recorded in black-and-white directly from in-situ surveillance cameras. The giant of the title is the surveillance camera, that ubiquitous "big brother." It includes sequences of a rainy airplane runway, traffic jams, shoplifters, and mansion gates. Seen this way, the city of Hamburg becomes a science fiction nightmare.

I recently spoke with a cameraman who said that digital technology is the cheapest and easiest to use and will replace film.

Consumer audio/video equipment is nearly all digital now. We can't forget that film, analogue, and digital video each have distinct characteristics as mediums and they aren't going away yet. Artists use each of them for different reasons. The British artist Steve McQueen favors the look of analogue video. When I showed his installation *Deadpan* [1998] in "Projects," I obtained a digital projector with the luminance he wanted. But Steve could not abide the pixilated effect of a digital projector. For his video installations, he tends to favor a softer, film look.

When choosing new work by artists, do you have to understand what images they have in their minds?

Getting to this level of understanding takes time. It all begins with a file folder with an artist's name on the label. Inside go bios, magazine articles, slides, my notes. I gather more information. From there, my interest could result in putting the work in a group show.

At the moment, I'm working on a Web site, called *TimeStream*, with Tony Oursler. The project is about how the moving image transmuted from medium to medium throughout history; now it is co-opting the hard drive. Tony tracks the evolution of virtual technologies and how they reflect popular belief systems. Web denizens can discover ways that radio, television, and now the computer have been used to communicate with the "spirit world." Connections can be made between points along a timeline to explore how technologies such as the camera obscura, influence machine, Leyden jar, magic-lantern theater, kaleidoscope, telegraph, and X-ray are precursors of today's Web art, cell phones, and surveillance cameras the size of vitamin pills. The Web artist Eric Rosevear is designing the site.

Is Tony working with Eric as he would with a master printmaker?

Top: Joan Jonas, *Revolted by the Thought of Known Places… Sweeney Ashtray.* Courtesy Pat Hearn Gallery, New York.

Bottom: Kristin Lucas, *Host*, 1997. Courtesy Museum of Modern Art, New York.

Definitely. Eric is a great guide because he is a talented artist and under-
stands the Web.

New media demands different kinds of exhibition spaces. It was once
common to think that the "black box" would replace the "white box."
Now in *Open Ends*,[4] your show *Video/Performance* is housed in a nat-
urally lit space with windows and tables and chairs like carrels in a
library; everything is placed at different levels and sizes. This is like a
departure from the spectacular ways of viewing video. Bill Viola's work
takes over a whole blackened arena, and Doug Aitken needs an ambu-
latory space where the viewer is able to move through corridors. Other
installations require a huge, darkened space. In the 1999 Venice
Biennale at the Corderie, videos by many different artists were pro-
jected on walls, floors, and ceiling, encouraging viewer interaction.

> I'm tired of the black box or a dark room, so with the *Video/Performance*
> show, I experimented. At one end I have a visual "stack," so at a glance
> the viewer can get an overview of the eight works in the show. The same
> eight tapes are each presented on monitors at individual kiosks, where
> viewers can have a one-on-one relationship with a particular tape. They
> sit down and put on a pair of headphones and can become immersed in
> a tape, which they can watch from end to end.

> *Video/Performance* came out of thinking about how video and per-
> formance art have shaped each other. Video and performance emerged
> and forged their individual identities as art forms in the 1960s and 70s.
> Often the two forms were used in tandem. Artists enthusiastically inte-
> grated the spontaneity of a one-time action with the stimulation of a new
> medium, especially one that included the possibility of "instant replay."
> In *Organic Honey*, Joan Jonas comes up with an idea, does a perform-
> ance, and changes it using the video as a working tool.

Instead of the petrified model, architects, directors, and curators are rec-
ognizing the museum as a new discursive arena to accommodate cul-
tural change, expanding audiences and new technologies. Examples
are the Kanazawa Museum in Japan or the Palais de Tokyo in Paris.[5] Will
MoMA take this opportunity to reckon with these issues?

> MoMA's new building is expected to open late in 2004, so in the mean-
> time we have an exciting exploratory phase. We will have a variety of
> spaces. Some of our works will be installed thematically, not just in a
> gallery for video. This is what our *MoMA 2000: Open Ends* series of
> shows was about. In the new building, Teiji Furuhashi and others will be
> shown in a multi-functional context. The walls will be wired, and we'll

Teiji Furuhashi, *Lovers*, 1994.
Courtesy the artist.

have certain experimental spaces for the newer technologies. We also
have our Web site not only for PR and our store, but for experimental
work, like the Oursler Web site we're commissioning. We're not locking
into particular technology now for the new building, since many new
developments will happen before we open in 2004. We will remain in
touch with Sony and other technological friends, open to systems just
coming down the pike. In our new building, we will have state-of-the-art
research centers with primary reference materials and, in most cases,
actual works—film, video, prints, drawings, etc. In the galleries there
will be cafés with kiosks and books, rest areas, and pods where you can
watch a video or a DVD or whatever the next thing is.

Over the next four years we will all be exploring new ways of in-
stalling in our new space, MoMA QNS, in Long Island City. It isn't as big
as our current exhibition spaces in Manhattan, but we'll try things out
there and in other satellite areas. The MoMA Web site will evolve so that
our public from around the world will access different aspects of the col-
lection and see new commissioned Web works. I imagine we'll stream
artists' videos, as well.

Like a virtual museum?

It will evolve so that you can visit MoMA from anywhere in the world, as
long as you can connect.

What about digital interiors, where the content is fleshed out by view-
ers who complete the story?

That sounds like the people who were working with hypertext from the
early 1990s. A lot still has to be worked out with what the user/viewer
wants. There are many couch potatoes, and few who want to mouse
around.

And billboards, video, and signage?

There are unbelievable opportunities. When I was in Seoul for the bien-
nial, we placed artists' videos on many of the electronic billboards that
light up the major intersections with flashing ads. In the near future,
video will cover the entire skin of a building.

Like Nasdaq in Times Square?

Yes, and more so. I've talked with people in the construction world and
there appear to be new ways of putting moving images on the skin of a
building, more like a contiguous pattern.

This is where the digital world and architecture come together.

When the Museum of Modern Art in Frankfurt was planning its new
building, Jean-Christophe Ammann, the Director, commissioned a new

installation by Bill Viola. The costs of making Bill's work came out of build-
ing construction expenses, rather than the museum's acquisitions budget.

Is it in your purview as a curator to request these changes?

Yes. When I began my curatorial work in the early 1970s, video attracted
me because it was on the cutting edge. Today, the new kid on the block
is digital art and I still have the urge to be on the cutting edge.

1. National Endowment for the Arts. **2.** See Barbara London, "Video Time and Space," *Media_City Seoul 2000*, exh. cat. (Seoul: Inter Media_City Seoul, 2000), pp. 21-27. **3.** Experiments in Art and Technology was formed in 1966 by Billy Kluver, Robert Rauschenberg, Robert Whitman, and Fred Walhauer as a not-for-profit service organization for artists and engineers. **4.** *Open Ends: 11 Exhibitions of Contemporary Art from 1960 to Now*, Museum of Modern Art, 2000-2001. **5.** The Contemporary Art Museum in Kanazawa will open in 2003; Palais de Tokyo is opening in the fall of 2001.

kasper könig
06/1997

Do you think that the purpose of art in public places has changed over time?

Yes, it has changed, but it is quite contextual. Münster is a specific situation. Here art is part of the environment; the public sees art without going to a museum or gallery. It is part of their daily life.

What is the purpose of public sculpture?

The purpose is the purpose of art: to question the autonomy and the function of art. There is no dogma in the relationship to outdoor art, because either it is art or it is not, and there are also the dialectics between the museum and the outdoors. This time in Münster, we will go so far as declaring the museum as public space.[1] The big difference is that in the museum you expect art and in the outdoors, you don't. So there has to be a plausibility within the works presented in the urban environment.

Yes, of course. But a dialogue like this began in the late 60s with pioneers such as Robert Smithson, Walter De Maria, Gordon Matta-Clark, Dennis Oppenheim, and others who were liberating art work from the museum as a democratizing or political act. The original purpose seems to have gotten lost. Not to offend you, but I feel that much of the work in Münster elaborates on existing history rather than challenging these and other past models.

I disagree. I like the new models. For instance, the Douglas Gordon work Between Darkness and Light (after William Blake) cannot be put into the category that you are citing. He deals with existing cultural entities like Hollywood films. He uses an underpass, which is really run-down, and turns it into a public movie theater. His piece also deals with modernism in a very straightforward way, having a box and a slab in the center. His point of departure was a Beuys piece in Münster in 1977—installed in the same underpass—but he made himself very independent of that model. The video installation of Diana Thater, Broken Circle, is another example. She deals with a building from the 12th century to which there was no access for 60 years. So now it is possible and of great interest to the public to be able to enter this tower. She could have easily fallen prey to the atmosphere of the building, as such. However, through her work, she established her own structure, and the two merge.

Beuys claimed that it is the responsibility of sculpture to question the predominant culture.

He felt that society tries to suppress this function
of art.

It's true, what he said, for music and poetry or any creative articulation.
If art didn't exist, it would be difficult to think of the future. One could
probably recall so many different kinds of things from Beuys. It's inter-
esting to talk about what he did in Münster, actually. For *Unschlitt/Tallow*
[1977], first he said, "To do something outdoors would be an aesthetic
waste." Then he managed a dialectical trick of finding a spot that was
kind of a social alibi; later, it was transported into the museum.

> When Beuys talks about "conflict potential," how
> does that fit with your thinking about public art?
> Do you feel that conflict potential is important in
> order to engage the viewer in an articulation of
> their thoughts and feelings?

Sure, conflict potential is important. However, provocation is not the
prime intent. It is more important to do something that is meaningful
also in terms of art. So you have to *insist* on art in order to change or
expand our idea of what art can be today.

> Tell me about Münster.

Münster is a Baroque town with a great Catholic tradition. Here there is
no fear of images, no fear of art. I think it is interesting to see how there
is a kind of relationship between two traditions: the Baroque and the
contemporary. Nam June Paik targeted that in Münster. His enormous
work [*32 Cars for the 20th Century: Play Mozart's Requiem Quietly*] looks
almost small. Each of the cars in his piece has its own cultural design
entity: the 20s, 30s, 40s, 50s, and even the Mozart *Requiem* on top of it all.
Suddenly you realize how fragmented and how non-holistic monu-
mental art is today, or can be, in relation to the Baroque. Still, he tackled
a very monumental, almost populist project. Seeing this work in regard
to the Schloss,[2] Carolee... the breadth of the 18th century is enormous,
and of course it was a completely different social structure. We are care-
ful not to make a sculpture park nor to put too much art in the city, but
to respect the normal routine and the anonymity of the city and not to
infringe on the privacy of the people.

> Do you see this as a subtle integration of works
> into the city?

Integration is a term I would disagree with. I think that art is a sort of
antipode to culture. Integration can be a method, but generally the
introduction of a work is a strange, unfamiliar moment. Art serves as

Hans Haacke, *Standort Merry-go round*, 1997,
installation view, *Sculpture. Projects
in Münster 1997*. Photo: Roman Mensing.

an initiation for opening a door, yet remains very much on the outside.

I found that the Hans Haacke, Nam June Paik, and Ilya Kabakov works shared introspective themes and were complimented by artists like Mark Dion, Andrea Zittel, Atelier van Lieshout, and Marjetica Potrč, whose works were containers or housings for solitary journeys. Perhaps isolation is a theme for the fin de siècle, though I have heard you say that you don't wish to impose "themes" on the exhibition.

First of all, we do not suppress anything. I think that if the curator has a theme, then quite often he manipulates, controls, and tries to influence the artist to succumb to an overall idea. The work of the curator is successful when it shows what the artist is thinking, when the curator disappears behind what is being presented. Otherwise, the curator quite often compromises the process. So you have to share a risk. It is more interesting, really, to take this idea of "theme" out of the process so that

Left: Nam June Paik, *32 Cars for the 20th Century: Play Mozart's Requiem Quietly*, 1997, installation view detail, *Sculpture. Projects in Münster 1997*. Photo: Roman Mensing.

Right: Ayse Erkmen, *Sculptures on the Air*, 1997, computer-simulated view of action, *Sculpture. Projects in Münster 1997*. Photo: Roman Mensing.

the artists themselves are quite often surprised by what they eventual-
ly do. I also don't agree with categories, necessarily. If somebody is using
concrete or is using film, video, or chewing gum, I don't give a damn as
long as the work has an intelligent haptic point—this, then, is its anchor.

How do you select the artists for this exhibit?
Select is not a nice word. I think a better word is invite. Yes... inviting the
artist and being happy if they accept that invitation and take it very seri-
ously. When they come, spend some time, ask questions; quite often it
is a "fishing expedition." We measure whatever they are proposing
against the best of what they have done. Some of them are very young
or haven't done much, because nobody has asked them so far. But I am
afraid of getting stuck in these categories because I think that they are
automatically unhelpful. There were quite a number of artists invited
because they participated in '77 and '87, like Carl Andre or Michael
Asher. Also, there are many works that remain permanently in Münster,
like the Siah Armajani, Ian Hamilton Finlay, and others; there was no
urgency to re-invite these artists. Instead, we invited artists who are
much older and those who are much younger. So you see, we have
expanded it to three generations. We also put a lot of research into see-
ing what's going on in Central and Eastern Europe, even if we only invit-
ed a few from that area—certain individuals who actually were profes-
sional artists doing monuments in the public context, quite often
compromising themselves with the system. Then there was another tra-
dition, which was unofficial and alternative. If you read the text of
Marjetica Potrč, it offers a more telling parallel than my saying it. The
Skulptur. Projekte catalogue is invaluable because it contains these
statements by artists. The whole process is also being followed on the
Internet in an even more detailed way.

What themes are coming out of Central Europe?
There are certain prevalent issues coming from Central Europe and
some of the artists dealt with them in a very subtle way. For instance,
there has been a discussion going on for a long time in Berlin, about the
memorial to the victims of the Holocaust. The way it is being handled is
ridiculous. A huge area in the center of Berlin has been proposed as a
site for a Holocaust monument. This can't be weighed from a capitalis-
tic point of view, yet the question is about the site's desirability and val-
ue for real estate concerns. The idea of trying to match the enormity of
the trauma with a piece of land of that magnitude... it doesn't match. I
think also that Hans Haacke's work Standort Merry-go round deals with

the desire, on the one hand, for monuments, and the question, "Is it still
possible to make monuments today?"

A few of the art works have become part of the physical life of the people in Münster, like Claes Oldenburg's *Giant Pool Balls* [1977]. What about the Fischli/Weiss garden?

The Fischli/Weiss, *Garten*, is temporary. It has been sited in a private space owned by a lady who was very skeptical about it. It is magical and does not insist on being unique. Hermann Pitz realized this idea but it had a very different meaning.[3] There is, of course, Alan Sonfist's work on LaGuardia and Houston in New York.[4] This Fischli/Weiss garden is very important. It's not about insisting on doing something that has never existed before; it has a very different, wider context. The artists that have been here before are not expected to be locked into a style, or to reproduce themselves or anyone else, contextually speaking. In 1987, Fischli/Weiss created a kind of pragmatic investors' model of a stupid building right next to the train station.[5] The house was also a subtle and creative critique of the other artists who had a certain theory about public art, namely, Scott Burton and Siah Armajani. This garden is also important because it is now contained in their "artistic biography."

Your interest in an artist is a long-term commitment. Acknowledging an artistic biography is a way of speaking of this commitment: yours to them and theirs to their work. In this context, the Paik work, using antique cars that represent six decades, speaks of the span of the artist's history, Münster's past, and former *Skuptur. Projekte* exhibitions created on this site.

Yes. Also, the exhibition is decentralized and meandering, which is very important because as you walk or bike from one place to another, what you see in the meantime might ultimately be your experience—and perhaps more interesting than what you actually confront. In your memory and when you think about it, perceptions change.

This attitude alludes to an Eastern way of thinking about paths and journeys, where the experience of the journey is as meaningful as the destination.

Yeah. Rückriem stated that in regard to the work he did in '77, "Two-thirds of the work is the 'siting' and only the other third is the work itself.

It's how you go from one place to another."[6] He intuitively did some- 131 thing which he later realized across from the church. Here was once a big high wall and after the wall there was a grand design for the university. He picked up on a memory of what the city was at one point and, without being sentimental, he showed its alienation as a quality. There's an interesting statement by a German artist who once said, "Modern art is very easy to understand; modern life is complicated." I think that sometimes artists focus on the artistic thinking and practice and come up with models, which do not have this application to life or to politics but are an entity in themselves.

In that they refer back to themselves?

Yes, but they are more than self-referential; they do something that hasn't existed prior, and that is a question of hope. It is a constructive, and an incredible, offering.

In that the artist imparts a new way of thinking to the observer?

Yes, but the artist is also an observer of himself or herself. You can't clearly participate or anticipate between reception and production. The criteria for understanding are quite often being offered along with the work. It's a very dialectical relationship between the maker, the viewer, the museum, or the places where you expect art. There really is no such thing as a public artist. Either there is a good artist, or one who is not serious or risk-taking. And the institutionalization of public art is something I am very skeptical about. Art becomes a kind of social engineering. It's the same thing as architecture. You can't limit an architect to being a specialist in building churches or synagogues or hospitals or schools. An architect should tackle any architectural challenge.

Do you often work with teams of artists or curators?

I'm continuously doing small-scale exhibitions at Portikus,[7] where I've been involved in different, changing roles as an editor, teacher, or whatever. The important thing is to work with a team because it's a very complex interrelationship, so I understand myself more as a coordinator. In Münster, Klaus Bussmann is the director of the Museum and Florian Matzner is the exhibition coordinator. The other people involved grew into this organically, and took on responsibility. It's a collective effort—collective in supporting particular possibilities and then really taking the risk and sticking to it, then not compromising. So you have to make a lot of changes, but it's interesting. When certain things are not possible,

you have to read that positively. You deal with the limitations and you focus. Some artists took great interest in knowing what other artists did, and others had no interest in that all. Not that they were indifferent to what their colleagues would do, but that was not their method. Which artist ended up in what space... it was a very organic process; there was no hassle. It's amazing how many of the artists, especially the younger ones, were there 10 years ago; one or two because they were assisting other artists, or they visited on their own, or came as students, or whatever. This is where professional records come in. I'm also very moved when I visit studios and find the catalogues from *Westkunst*[8] or Münster in their libraries. We are trying to put together a catalogue which we feel is useful; it has sources, it gives a lot of information, it's usable as a book for people who are very interested in particular positions of artists within a different context.

As the Director and founder of Portikus, can you describe what this space is about?

It's really a very simple space. It's attached to a Classical ruin of the city and university library here in Frankfurt. It was destroyed at the end of the war. That gives rise to a wonderful irony, because in Classicism the ruin is an idea of a stepping stone, and then through the trauma of history it inadvertently became a ruin again. It was standing around for a long time and no one knew what to do with it. This was pointed out to me by some artists when I was offered the chance to come to Frankfurt to teach here at the school, and I said, "Yeah, I'd like to do that." I'm not an artist, but I was living or working in the context of artists and I needed some kind of a vehicle of my own to mount ongoing exhibitions or events. Then, a film was being made there with stark lights on the façade of the remaining portico. It was a postmodernist experience, like that described in the Venturi/Brown book, *Learning from Las Vegas*.[9] That was it for me! With the design help of two young architects, we just attached a big exhibition box behind it that isn't bigger than the walkway, and put containers on either side. It inadvertently offers a criticism of all the new museums and other celebrated architectural commissions. They are architectural alibis for cultural gems and I'm really skeptical of that. Most of the new museums have been really pretty bad, vain, self-serving, architectural pipe dreams.

Do you think that these museums are hostile to art?

Indifferent to art—quite often not even hostile. If it would be hostile, then there would be an intention. Quite often architects think that architec-

Diana Thater, *Broken Circle*, 1997, installation view, *Sculpture. Projects in Münster 1997*. Photo: Roman Mensing.

ture is the mother of the arts, which, out of its tradition, makes sense as
the ultimate form integrating all of the arts.

What motivates your choice of exhibitions for Portikus?

There's a relationship to the Städelschule—in order to make it interesting for an artist and guest lecturer to have something beyond working in the school with students, to have an exhibition of their own and a catalogue. So it's in between a museum and a private gallery. It's not the bread-and-butter issue, and it's not like "representation." It's a challenge, this white cube.

Who are you showing at Portikus now?

Matthew Barney. He transformed it into a showing room for his new work which opened last week, *Cremaster 5* [1997].

Matthew Barney won the Hugo Boss Prize last year.

Yes, he's considered the darling of the art world, and that is an image which can easily turn against the artist, too. I find this star system really distasteful. Quite often the substantial contribution these artists make can be separated from the secondary aspect around them.

Not to confuse the art with the art-maker....

Not to confuse the art and its quality—what is there—with the context in which it is being presented. Yes, continuity is very important—and discontinuity, as well. Not getting stuck, like in producers of brand names. It's very perverse.

The continuity of the exhibitions Klaus Bussmann has done at the Landesmuseum in Münster, plus the *Skulptur Projekte*, is significant. In the central court of the museum there have been a number of large-scale, solo exhibitions by Sol Lewitt, Carl Andre, Thomas Schütte, or Per Kirkeby that cannot be separated from this *Projekte* exhibition. Furthermore, it affirms an inner structure and legitimacy to the museum and its function in the community. We're not involved in some kind of traveling circus.

Are you are committed to taking risks?

Yes, being able to change, not repeating mistakes, or making a theme too important!

Well, yes, this is ideal, but some curators fall short here.

There is a method of protection by not making the theme overly important and allowing a sense of proportion, a sense of "give-and-take"; otherwise, the exhibition becomes incredibly pretentious and condescending.

Who is interested in the curator looking at their own navel? I don't think the artists or the interested public want to know the opinion of the curator; they want to see what the artists are doing. This is very important. Ultimately, the work of the curator is successful when they disappear behind what is being presented and still have an intellectual overview. Also, being able to let go, and to give.

1. The exhibition is *Sculpture. Projects in Münster 1997*, held from June 22 to September 28. **2.** The Schloss is the Baroque castle which once housed the Prince-Bishop and now supports the University. The architect was Johann Conrad Schlaun. **3.** Hermann Pitz, *Innen/Aussen*, 1997. **4.** Alan Sonfist, *Time Landscape*, 1978. **5.** Peter Fischli/David Weiss, *Haus*, 1987. **6.** Ulrich Rückriem, *Dolomit zugeschnitten*, 1977. **7.** Portikus is the exhibition space associated with the Städelschule (Staatliche Hochschule für Bildende Kunst), an art school in Frankfurt. **8.** *Westkunst* is an exhibition that was organized by König in Cologne in 1979. **9.** Robert Venturi, Denise Scott Brown, and Steven Izenour, *Learning from Las Vegas* (Cambridge, Mass.: MIT Press, 1972).

biographies

dan cameron

is Senior Curator at the New Museum of Contemporary Art in New York City. He has published over two hundred texts on art in various international publications, including *Artforum, Arts Magazine, Parkett, Frieze*, and *Flash Art International*. He has contributed to numerous museum catalogues for such institutions as the Royal Academy of Arts, London; Stedelijk Museum, Amsterdam; Carnegie Museum, Pittsburgh; Center for Contemporary Art, Glasgow; and Berkeley Art Museum, Berkeley. As an independent curator, Cameron has organized large-scale exhibitions of contemporary art at several major venues, including the *Aperto* at the Venice Biennale (1988); *What is Contemporary Art?* (Rooseum, Malmö, 1989); *Future Perfect* (Heilengenkreuzerhof, Vienna, 1993); *Cooked and Raw* (Reina Sofía National Museum Art Centre, Madrid, 1994-95); and *Threshold* (Fundaçao Serralves, Oporto, 1995). He attended Syracuse University and Bennington College, earning a B.A. in 1979.

hou hanru

was born in Guangzhou, China, and has lived and worked in Paris since 1990. He teaches at the Rijksakademie van Beeldende Kunsten, Amsterdam, and is a member of the global advisory committee of the Walker Art Center, Minneapolis. As a curator, his exhibitions include: *Out of the Centre: Chinese Contemporary Art* (Pori Art Museum, Pori, Finland, 1994); *Parisien(ne)s* (Camden Arts Centre, London, 1997); *Hong Kong, etc.*, Johannesburg Biennale (1997); *Gard de l'Est* (Casino, Forum of Contemporary Art, Luxembourg, 1998); *Unlimited NL 2* (De Appel Foundation, Amsterdam, 1999); Photography Biennale (Centro de la Imagen, Mexico City, 1999); French Pavilion, Venice Biennale (1999); *Fuori Uso* (Pescara, Italy, 2000); *Shanghai Spirit: Shanghai Biennale 2000* (Shanghai Art Museum, Shanghai, 2000); *The Mind on the Edge (of the New Centres)* (Circulos de Bellas Artes, Madrid, 2000). He has served on international juries in Europe, Asia, and the Americas, as well as lecturing at a number of international institutions and writing for art magazines and gallery catalogues.

yuko hasegawa

is the Chief Curator of the new Contemporary Art Museum, Kanazawa, Japan (opening 2003). She graduated from Kyoto University Law School in 1979, and holds a Master's Degree from the Tokyo University School of Fine Arts and Music (1989). After working as a curator at the Mito Arts

Foundation Contemporary Art Gallery from 1992 to 1993, she was a vis-
iting curator at the Whitney Museum of American Art on an ACC grant.
As a curator at Setagaya Art Museum, Tokyo, from 1993-1999, she organ-
ized *Cai Guo Qiang: Chaos* (1994) and *De-Genderism: détruire dit-elle/il*
(1997). As an independent curator, she organized *Liquid Crystal Futures:
11 Contemporary Japanese Photographers* in Tokyo, which then toured
five major European cities (1994-1996), and *Fancy Dance* in Seoul (1999).
She joined the jury of the 1999 Venice Biennale, and is a Board Member
of CIMAM. She also teaches at Tokyo University of Fine Arts and Music,
and is the curator of the next Istanbul Biennial (2001).

mária hlavajová

earned an M.A. in Cultural Studies from Comenius University in
Bratislava. She worked with the Soros Center for Contemporary Arts as
its Program Coordinator, Deputy Director, and Director from 1992 until
1999. Since 1998 she has been a faculty member at the Center for Cura-
torial Studies at Bard College, New York. Recently she has been appoint-
ed Artistic Director of the Center for Contemporary Art Begane Grond
(Ground Floor) in Utrecht, The Netherlands. Since the early 1990s she
has curated and co-curated numerous exhibitions, mainly of Slovak,
Czech, and Central European artists, including the exhibitions *Interior
vs. Exterior, or On the Border of Possible Worlds* (Bratislava, 1996), *There
is Nothing Like a Bad Coincidence* (Bratislava, 1998), *Midnight Walkers,
City Sleepers* (Amsterdam, 1999), as well as one-person and group exhi-
bitions of Roman Ondák, Boris Ondreicka, Denisa Lehocká, Paweł
Althamer, Roza El-Hassan, and other artists. She has contributed to con-
temporary art magazines such as *Atelier* (Czech Republic), *Kalligram*
(Slovakia and Hungary), *Profil* (Slovakia), and *Nu: The Nordic Art Review*.
She is based in Amsterdam and Bratislava.

kasper könig

has recently taken over as Director of the Museum Ludwig in Cologne.
He was formerly Director and professor at the Städelschule in Frankfurt,
where he also founded and directed the exhibition space, Portikus. In
1977, 1987, and 1997, he co-organized *Sculpture. Projects in Münster*
with Klaus Bussmann. He has served as curator for numerous important
exhibitions, including *Westkunst* (Köln, 1979), *Von Hier Aus* (Düsseldorf,
1984), *The Broken Mirror* (with Hans-Ulrich Obrist, Vienna, 1993), and
Eight People in Europe (Gunma, 1998). He recently worked as the Artistic

Director of the art exhibition at Expo 2000 in Hannover, Germany. He
studied art history at the Courtauld Institute of London University from
1963 to 1964, and anthropology at the New School for Social Research
in New York in 1965. In 1968 he worked with Andy Warhol at the Factory
in New York, organizing an exhibition of the artist's work for the Moderna
Museet in Stockholm. He then taught at the Nova Scotia College of Art
and Design in Halifax until 1978, when he returned to Germany.

vasif kortun

is the founder and Director of the Istanbul Contemporary Art Project,
which opened in 1998. Between 1994 and 1997 he worked as the Director
of the Museum of the Center for Curatorial Studies, Bard College, New
York. He served as the chief curator and Director of the 3rd Istanbul
Biennial in 1992. Most recently he organized *Young Art in Ankara—3*
(Ankara, 2000), *Confessions of a Voyeur* (Istanbul, 2000), and *Unlimited
4* (Amsterdam, 2001). He is currently working on a contemporary art
museum, Proje 4L, that will open in September 2001 in Istanbul. His writ-
ings have appeared in *Flash Art International*, *Art Asia Pacific*, *New Art
Examiner*, *Art Fan*, and other magazines, and he has contributed to
numerous exhibition catalogues. He serves on the global committee of
the Walker Art Center, and is a member of VOTI and IKT. Kortun is the
editor of a quarterly contemporary art magazine, *RG*, published in the
Turkish language.

barbara london

is Associate Curator in the Department of Film and Video at the Museum
of Modern Art in New York. She previously worked at MoMA as a Cura-
torial Assistant for Video (1975-1981), and as Assistant Curator of Film and
Video (1981-1993). In 1974 she founded the Video Exhibition Program at
MoMA and has since been active in creating links between the electronic
arts and more traditional art mediums. Among the many exhibitions she
has organized at MoMA are *Video Spaces: Eight Installations*; *Music Video:
The Industry and its Fringes*; *New Video: Japan*; *Myth, Video and the
Computer*; *Video and Language*; *Video Art: A History*; *Video from Latin
America*. She has organized numerous solo artist projects, including work
by Steve McQueen, Bul Lee/Chie Matsui, Zhang Peili, Gary Hill, Judith
Barry, and Nam June Paik. Her essays have appeared in many exhibition
catalogues and art magazines. She holds a B.A. from Hiram College in Ohio,
and an M.A. from the Institute of Fine Arts at New York University (1972).

rosa martínez

is an art critic and independent curator based in Barcelona. She was co-curator of *Manifesta 1* (Rotterdam, 1996), and worked as artistic director of such events as the 5th Istanbul Biennial (1997), the 3rd SITE Santa Fe Biennial (New Mexico, 1999), and the 4th EVA Biennial in Limerick, Ireland (2000). She was one of the five members of the 48th Venice Biennale's International Jury (1999). Since 1998 she has been the curator of the International Project Rooms at ARCO, the Contemporary Art Fair in Madrid. A frequent contributor to newspapers and magazines, she is the Spanish correspondent for *Flash Art International*. She has recently worked on the shows *Living and Working in Vienna* (Kunsthalle, Vienna) and *Streams in a Large River* for the PICAF 2000 Arts Festival in Pusan, Korea. She is also the Artistic Director of the 1st Kathmandu Biennial to be held in 2003 in Nepal.

hans-ulrich obrist

was born in Switzerland and currently lives and works in Paris. Since 1993 he has run the program *Migrateurs* at the Musée d'Art Moderne de la Ville de Paris, and he has been a curator at the Museum in Progress in Vienna. He was the founder of the migratory Museum Robert Walser (1993) and of the Nano Museum (1996). He has organized numerous exhibitions since 1991, including *The Kitchen Show* (St. Gallen, 1991); *The Broken Mirror* (with Kaspar König, Vienna, 1993); *Life/Live* (with Laurence Bossé, Musée d'Art Moderne de la Ville de Paris and Centro Belem, Lisbon, 1996); *Le Jardin, La Ville, La Mémoire* (with Laurence Bossé and Carolyn Christov-Bakargiev, Villa Medici, Rome, 1998-2000); *Laboratorium* (with Barbara Vanderlinden, Antwerp, 1999); *Retrace Your Steps: Remember Tomorrow* (Sir John Soane Museum, London, 1999-2000); and *Media_City Seoul* (South Korea, 2000). He has edited the writings of Gerhard Richter, Louise Bourgeois, Gilbert and George, Maria Lassnig, and Leon Golub.

harald szeemann

holds degrees in art history, archaeology, and journalism. Between 1961 and 1969 he served as Director of the Kunsthalle Bern. Since then he has been active as a freelance curator, organizing such major exhibitions as *When Attitudes Become Form* (1969), *Happening and Fluxus* (1970), *documenta 5* (1972), *Bachelor Machines* (1975), *Monte Verità: Mountain of Truth* (1978), *Charles Baudelaire* (1987), and *Austria in a Lacework of*

Roses (1996). He was co-organizer of the Venice Biennale (1980), where he created *Aperto*, an exhibition for younger and emerging artists. Since 1981 he has been an independent curator affiliated with the Kunsthaus Zurich. He has organized solo shows of Francis Picabia, Josef Albers, Roy Lichtenstein, Sigmar Polke, Cy Twombly, Eugène Delacroix, Piet Mondrian, Georg Baselitz, Niele Toroni, Joseph Beuys, and Bruce Nauman. He was the Director of the 1997 Lyon Biennale, a Commissioner of the 1997 Kwangju Biennial, and has worked as Director of the Venice Biennale in 1999 and 2001.

carolee thea

is a writer, artist, curator, and contributing editor at *Sculpture Magazine*. In the past five years many of her articles and interviews with artists and curators have been featured in *Sculpture Magazine, TRANS>arts.cultures.media, Shijue 21, New Art Examiner, Artnet, NYArts Magazine*, and *ArtNews*. Among her recent essays are "Berlin Glitzkrieg," "Robert Irwin: De-objectifications for Philosophic and Actual Bodies," "Blockbuster Art Exhibitions in Europe and the United States," and "The Guggenheim Museum in Bilbao." She attended Skidmore College and Columbia University, and in 1976 earned an M.A. at Hunter College, City University of New York. She was awarded an NEA grant in 1990 and is presently a member of Arttable and AICA. She has served on the Editorial Board of *HERESIES: A Feminist Publication on Art and Politics* (5th issue, 1978), and has taught at Pratt Institute, Parsons School of Art, College of New Rochelle, and other universities. She lives and works in New York City.

Designed by Mats Håkansson, New York. Typeset in Univers Light, Regular, Bold, Black, and Italic, Filosofia Regular and Italic, and Helvetica Inserat, using Quark Xpress on a Macintosh G3. Printed and bound in Belgium by Snoeck-Ducaju & Zoon, Gent.